Quilt National 2013
THE BEST OF CONTEMPORARY QUILTS

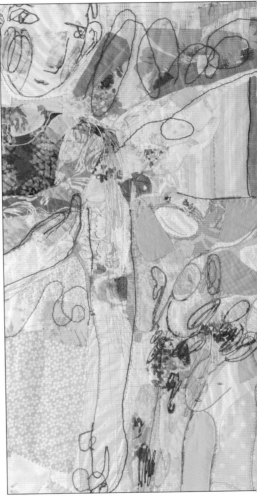

Top: Susan Lenz, *Circular Churchyard*
Middle: Anne Smith, *Gabriel*
Bottom: Marianne R. Williamson, *Hidden Falls*

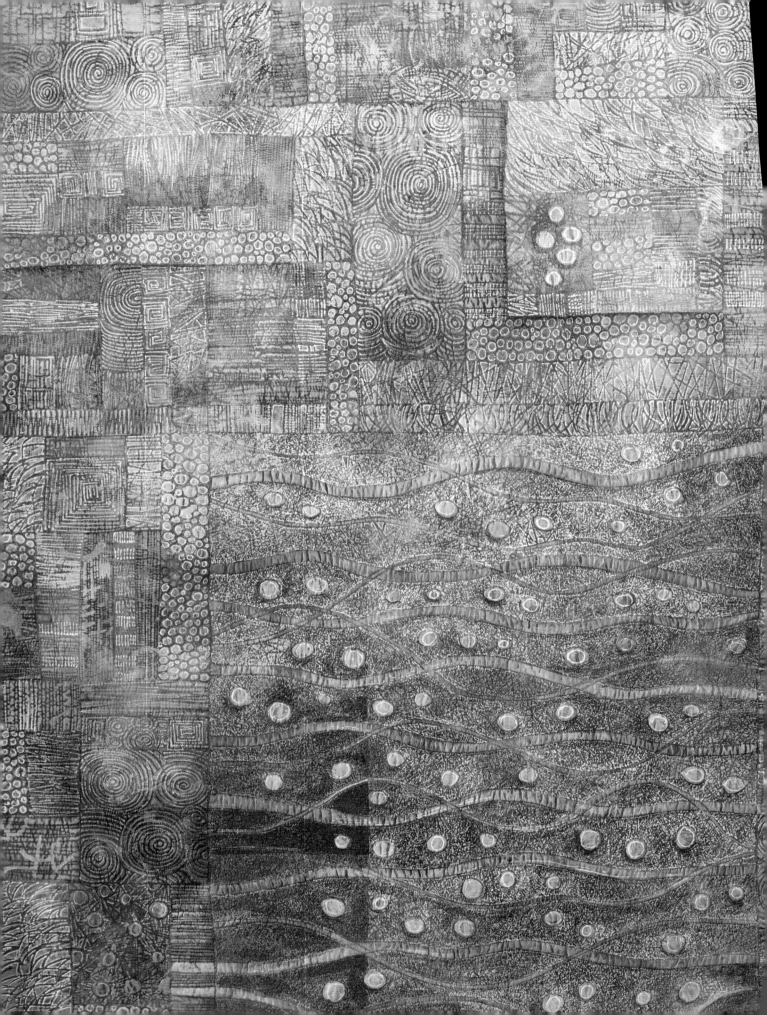

Quilt National 2013
THE BEST OF CONTEMPORARY QUILTS

Co-produced by
The Dairy Barn Cultural Arts Center
and Dragon Threads Ltd.

THE
DAIRY BARN
ARTS
CENTER

Dragon Threads

Left: Deidre Adams, *Tracings III*
Top: Laura Fogg, *Jammin'*
Bottom: Kate Themel, *Morgan's Flight*

QUILT NATIONAL
DIRECTOR: **KATHLEEN M. DAWSON**

EDITOR IN CHIEF: **LINDA CHANG TEUFEL**

GRAPHIC DESIGNER: **KIMBERLY KOLOSKI**

PHOTOGRAPHERS: **GARY J. KIRKSEY**
LARRY HAMEL-LAMBERT

FRONT COVER QUILT: **MARIANNE BURR**

BACK COVER DETAIL: **KAREN RIPS**

BACK COVER QUILT: **PATTY HAWKINS**

FRONT FLAP QUILT: **SUSAN V. POLANSKY**

BACK FLAP QUILT: **ROBIN SCHWALB**

ENDPAPER QUILT: **PAULA KOVARIK**

LIBRARY OF CONGRESS CONTROL NUMBER:
2012955528

QUILT NATIONAL 2013:
THE BEST OF CONTEMPORARY QUILTS

CO-PRODUCED BY
THE DAIRY BARN CULTURAL ARTS CENTER &
DRAGON THREADS LTD

1ST ED.

INCLUDES INDEX.

ISBN# 978-0-9818860-4-6 (HARDCOVER)

1. ART QUILTS-UNITED STATES-HISTORY-21ST
CENTURY-EXHIBITIONS

I. DRAGON THREADS.
II. DAIRY BARN CULTURAL ARTS CENTER.
III.TITLE

PRINTED IN THAILAND

ALL RIGHTS RESERVED.

9 8 7 6 5 4 3 2 1

490 TUCKER DRIVE
WORTHINGTON, OH 43085

WWW.DRAGONTHREADS.COM

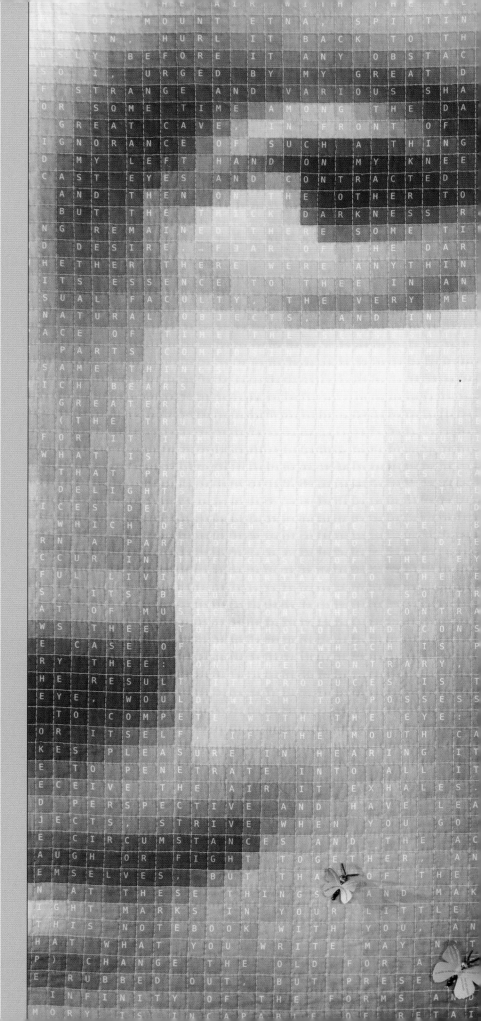

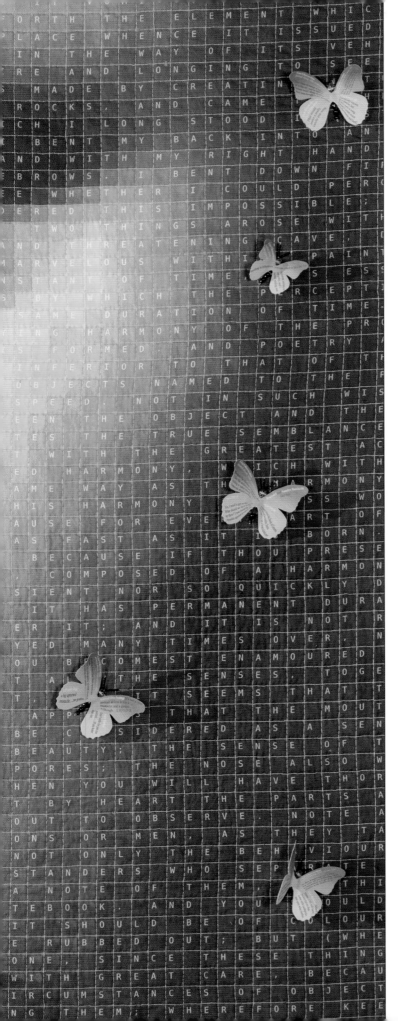

CONTENTS

John Lefelhocz,
Mona in the Era of Social Butterflies

Eleanor McCain and Kevin Womack,
Swaddling to Shroud—Birthing Bed

FOREWORD

The Dairy Barn Arts Center is pleased to present to you Quilt National '13, the 18th juried biennial international exhibition of art quilts. In the summer of 2012, we accepted 851 quilt submissions from 44 states, five Canadian provinces, and 16 countries. After a two-day process, the jurors managed to select the magic number of quilts, 85.

As the new director of the Dairy Barn Arts Center, the process was one of learning about the history of this great exhibit, learning about the artists themselves, and getting the chance to see every entry as they came into the new online system. The jurors were able for the first time to spend time looking at the quilts and scoring them prior to coming to the Dairy Barn and with those scores they reduced the number for further consideration by about half. The two-day process of working with the jurors and listening to their thoughtful comments gave me total respect for not only the jurors, but the artists, the wonderful staff, and the volunteers that make the process and the exhibit internationally known and respected all over the world.

What struck me the most was the diversity of materials, designs, fabrics and visions that these 458 artists utilize to make these visions of beauty. Even though only around 10% of the submitted quilts are chosen for the exhibit, one must thank all of the artists who put hours of work into their pieces. It is all of them that keep transforming the art form that we know as contemporary art quilts today.

We thank our members and supporters who provide support for the Dairy Barn with over 85% of the funding for the operations as well as the sponsors of the individual Quilt National Awards. These organizations, businesses and individuals allow us to reward quilters for their incredible artistry. We also thank our general supporters of Quilt National who make this exhibition financially viable as well as the new publisher of the Quilt National '13 catalog, Linda Teufel, Dragon Threads Ltd.

I am pleased to present to you Quilt National '13 and this beautiful collection of contemporary art quilts. As we celebrate 35 years presenting Quilt National, we thank you for your appreciation of this art form. We also thank the artists for giving us the opportunity to share another 85 quilts from the world's best right here in Southeastern Ohio.

Jane Forrest Redfern
Executive Director
Dairy Barn Arts Center

INTRODUCTION

Quilt National '13 represents the 18th biennial presentation of this unique exposition of the art quilt medium. Established in 1979 as the inaugural exhibition of The Dairy Barn Arts Center, its longevity is fueled by both the growing ranks of artists who embrace the medium and the general population's insatiable interest in this particular form of fiber art.

The breadth and depth of the artistic submissions never ceases to amaze me. As Quilt National Director, every two years I have the enviable task of being allowed to preview the extraordinary collection of entries from which this exhibition of 85 pieces will be chosen. Over the past four exhibitions, I have watched surface design expand to include all manner of fiber manipulation—dye, discharge, digitally created design, organic dye, manipulation by the elements. Artists from all over the world have literally taken apart the traditional quilting processes. They have elevated the creative process from a craft that utilized scrap fabrics to an art form that begins with the creation of the fabric itself. While basic techniques—piecing, appliqué, embroidery—are still in evidence, the basic nature of the fiber "building" blocks are broadened by the inclusion of contemporary techniques such as computer design, digital imagery, a variety of printing techniques (mono print, screen print, computer print).

As the art quilt continues its progression from craft to art, the element of artistic message continues to flow. In addition to the "traditional" nature/art representations, you can find much commentary on the contemporary political issues that populate any artistic medium. Quilt National '13 is an excellent representation of both the art quilt medium and our current socio-economic environment.

Quilt National had quite an interesting journey over the past two years. In addition to well-received appearances around the United States, it took a journey to the European Patchwork Meeting in St. Marie aux Mines, France in September 2011. While the European visitors checked out the Quilt National selections from 2009 and 2011, I was able to check out the state of the European and Middle Eastern art quilts. I was delighted to find that the art quilt is thriving in those parts of the world as it is in the United States, Australia, Japan, and Korea. We are very pleased that Quilt National '13 includes multiple representatives from Germany, Belgium and Switzerland among other countries.

The Quilt National '13 jury process made the transition to completely digital entries in 2012. I understand that the process was probably intimidating to some of the artists (as well as my technology-challenged self), but I have to admit that the technology *might* have its place. In past years, I have spent hours and hours entering data, transferring images,

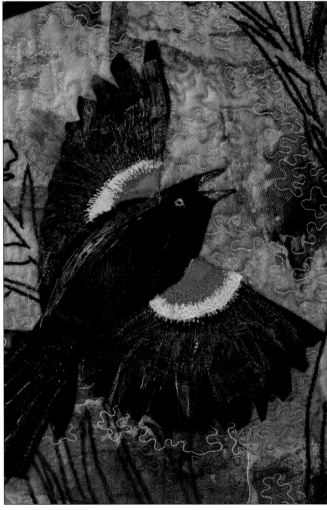

Top: SusanCallahan, *2 Top*
Bottom: Carol Goossens, *As Summer Slowly Fades...*

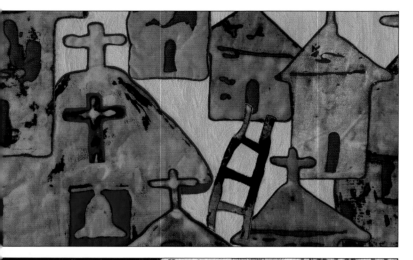

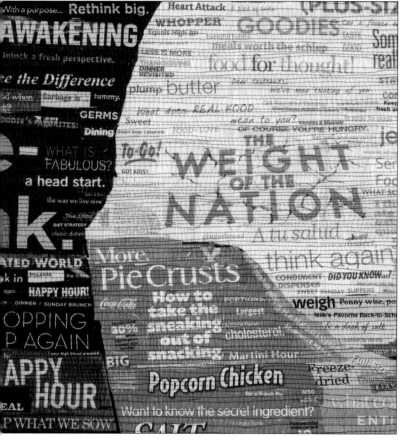

and preparing the presentation for the jurors. This year all of that manual labor was contributed by the individual artists and in the space of about an hour, everything was downloaded, organized and ready to go. I have to admit that the overused term "amazing" applies in this situation! We were also able to allow the jurors the opportunity to conduct the first round of the judging in their own homes at their own pace. Instead of an initial marathon four-hour session in which each piece received 10 seconds of consideration, the jurors were able to work at their own pace, consider each work, zoom in to take a closer look at details, and even return to revisit choices. Their assessment of that process was that while it was time-consuming—they figured about 12 hours of actual viewing time for the first round alone—each individual work received better and more considered assessment than it had in the past. That also allowed us to expand the time for the overall jury process. The second and third rounds were conducted at 15 seconds instead of 10; sometimes, because the jurors felt that they were familiar with the work, it seemed that we were waiting for the images to progress! It allowed more time for dialog between the jurors without the deadline of plane flights looming over us.

The ultimate result is the collection of quilts that you will find on the ensuing pages. There are quilts that represent artists from 27 of the states and 12 artists from seven different countries. Of course, they are much more beautiful and impressive if you choose to view them in person! We hope to see you in Athens the summer of 2013.

Kathleen M. Dawson
Quilt National Director

Top: Mary Rowan Quinn, *High Expectations*
Bottom: Deb Cashatt, Kris Sazaki, *American Still Life: The Weight of the Nation*

Linda Colsh

The honor and responsibility of being asked to jury Quilt National, with such a large pool of high-quality submissions, brings long hours and hard choices. This year, for the first time, the jurors worked remotely for the first round. As always, several early rounds are silent; so a remote first round is no different in that respect. The increased time available for a remote first round enables each juror to give individual works more attention than ever before possible—attention that, I believe, is a great plus for entrants.

Previous Quilt National first rounds showed each work for a few seconds. Jurors' decisions were literally made in a flash. Penny, Judith and I were able to spend as much time as we wished with a work. We could question appropriateness of materials and technique and assess the relevance of intent and message. Having the luxury of time to evaluate, study, get to know, and ultimately rate work using Quilt National's rating system is a step forward that clearly benefits artists.

This enhanced attention means first impressions are more fully considered judgments. Familiarity with the individual pieces carried on to later rounds. Also, we had time to go back when needed to review our charge. The charge defines Quilt National "as a showcase for *new* work that provides the viewer with an appreciation of the variety of techniques and innovative trends in the medium of layered and stitched fabric." The charge commissions the jury to "select works that represent unique approaches to the medium and demonstrate the breadth and diversity of contemporary expression while continuing and expanding the time-honored traditions of the art of quilting."

Almost all entries referenced the art of quilting, from the naïve appliqué of Pamela Allen's *My Town by the River*, to traditional blocks pieced from fabric of striking imagery by Eleanor McCain & Kevin Womack's *Swaddling to Shroud—Birthing Bed*, to the perhaps most expansive stretch of "layered and stitched" demonstrated in Kerby Smith's *Graffiti Series—Chain Link*.

Linda Colsh, *Defiant*, 70"H X 72"W

The challenge for the Quilt National jury is to identify submissions that move the medium forward and push into new arenas: artwork that is new, fresh, and unique, and that goes beyond what has been said and done before—artwork with impact.

Impact distinguishes work that succeeds in concept and displays accomplished design from work that does not achieve at the highest level. Impact can be primarily visual, that is, information perceived from the photos; or the impact can be in content, which is read or interpreted.

Visual impact, the power of the design to grab a viewer's attention, is hugely important, particularly with a large field of entries. Strong design, good composition, the Wow! factor are vital to determining which works continue from round to round. Charlotte Ziebarth punctuates the calm of water flowing across her *Reverberations* with surface ripples and motion-distorted rust-colored shapes. The serene rectangle of Karen Rips' *High Water Mark*, zen-like circle of Brienne Brown's *Moonset*, elegant spiral of Paula Kovarik's *Round and Round It Goes*, large-scale Xs of Cathy Kleeman's *Post No Bills*, and stately verticals of Cynthia Corbin's *Threadbare* all make strong, dramatic visual statements.

The placement and scale of the forms in *Decay* by Leslie Bixel illustrate the power of simple shape and highly contrasted value. In *Storm*, Diane Firth cleverly uses displacement of the picture surface worked on mesh to make shadows on the wall that echo the two whorls of simple teardrop forms and create the surprise and contrast of mass and no mass. The multilayered impact of Shin-Hee Chin's *Florence Nightingale* strikes the viewer first with color, shape and value—through a second reading that reveals imagery and symbol—and then, the impact of the piece is further underlined by unique construction technique.

Content, the artist's statement and the significance a viewer finds in a piece, takes longer to perceive but it often is the slower-developing impact that holds the viewer's attention—staying power. The conversation across the empty space of Mary Ann Tipple's diptych *The Conversation* speaks volumes. To the literal imagery of *Descent into Darkness: The Boys of the Mine*, Patricia Kennedy-Zafred adds poignancy with superimposed text of place.

Who doesn't love a mystery? We probe the encyclopedic, eccentric collection of artifacts on Brooke Atherton's *Spring Field*, wanting to know what they are and why they were chosen and presented together. Why is Kate Gorman's *Bernadette in Artichokes*?

One can only imagine the twists and turns of Kathy Nida's plot for *Spread Out on the Pavement* with its decapitated head, "disturbed" truck, filed papers, and steaming picnic. Rachel Brumer's unexpected juxtaposition of objects, some hanging in space and others drastically cropped, keeps the viewer looking from one panel of *Large Regional Still Lives* to another, trying to put together a narrative.

Benedicte Caneill gives a clue in the title *Grieffiti*, yet leaves the viewer to fill in the blanks and derive meaning from her scratched, textured marks. Arle Sklar-Weinstein fills pockets with story-telling bits, while the red tape of her *Truth or Consequences* turns Danger to Anger (or vice versa).

Heavy with references and deep in symbolism, *Mona in the Era of Social Butterflies* ties levels of meaning in knots before the viewer's eye. Beyond the iconic Mona Lisa image shining out from that most modern icon, the iPad, the viewer is presented with a puzzle of Chuck Close-like gradated squares, most with a tiny letter or symbol. Blue butterflies drift down on the piece carrying further messages on their wings. John Lefelhocz gives us, in Winston Churchill's words, "a riddle, wrapped in a mystery, inside an enigma" but what is the key?

Thank you to Quilt National and the Dairy Barn for giving me the honor and opportunity to jury this premier exhibition. To every artist who entered Quilt National 2013, thank you for submitting your artwork and sharing it with me and my fellow jurors, Penny McMorris and Judith Content. Congratulations to the 85 we chose to exhibit their work in Quilt National 2013.

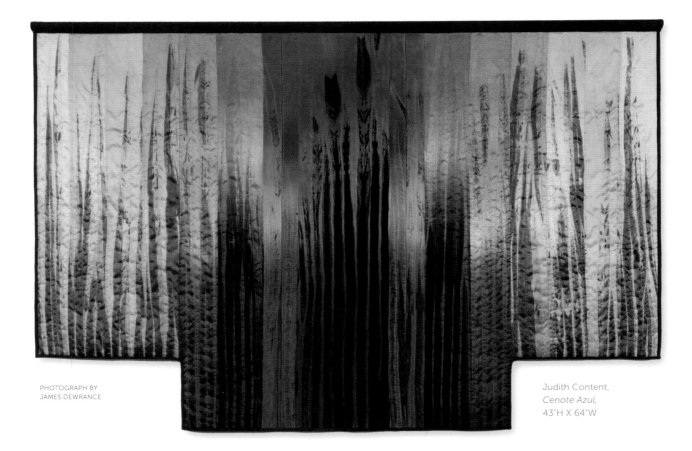

PHOTOGRAPH BY
JAMES DEWRANCE

Judith Content,
Cenote Azul,
43"H X 64"W

Judith Content

What was I looking for? What was I hoping to see when I sat down in front of my computer, in the quiet of my studio, to do the preliminary jurying of Quilt National 2013? I was looking for pieces which took my breath away. I was looking for work resonating with confidence and resolution. I was hoping for pieces which broke new ground and explored new ideas. I was looking for compelling works of art, which not only deserved, but demanded to be included in Quilt National 2013.

For almost ten hours I poured over the more than 800 entries, zooming in to see the details, pondering the scores I would give. Time flew by and I became immersed in a vivid world of color, composition, surface design and texture. Strong pieces leaped from the computer screen and earned themselves a four. Subtle pieces earned fours when discerning detail shots revealed unseen strengths. I gave low scores to pieces that were unresolved, showed poor workman-

ship, weak artistic standards or were poorly photographed.

Several pieces did take my breath away during the initial viewing and I was committed to them throughout the jurying process. Dinah Sargeant's *Old Child* impressed me with its irrepressible sense of movement and lovely use of color and light. Rachel Brummer's brilliant use of contrast heightened the sense of intrigue in her piece *Large Regional Still Lives*. Robin Schwalb and Kathy Weaver are both expert storytellers. Their fresh new work *Jive Boss Sweat* and *Biomechatronics Development Lab 2 v 2*, respectively, made spectacular use of color and composition underscoring the narrative nature of their work.

I expect my background in shibori dyeing predisposes me to a love of surface design. Therefore it wasn't surprising I responded so strongly and favorably to pieces such as *Tracings III* by Deidre Adams,

El Cortez, Las Vegas by Lisa Kijak, *Bella Woods* by Nelda Warkentin, *Urban Melody* by Judith Plotner and *Decay* by Leslie Bixel. However, these pieces embodied much more than beautiful cloth. Strong compositions, dynamic use of color and singular voices elevated them above the competition.

Everyone knows that excellent photography, in particular the detail, is crucial to receiving a high score from a juror. Kevin Womack's and Eleanor McCain's collaboration *Swaddling to Shroud—Birthing Bed* came to life for me when I saw the illuminating detail of baby fists, feet and faces. The details of *Round and Round it Goes* by Paula Kovarik and *Salt and Pepper* by Miriam Nathan-Roberts revealed an extraordinary mastery of the stitch. Elin Noble's unique approach to quilting was effectively illustrated in her detail of *Fugitive Pieces 11*. I might never have grasped the full impact of *SpringField* by Brooke Atherton without a detail of her astonishing use of embellishment.

Working at the Dairy Barn under the guidance of Kathleen Dawson and in the company of co-jurors Penny McMorris and Linda Colsh, was a privilege.

Refining the exhibition took two days of intense scrutiny and conversation amongst us jurors. It was an arduous but exhilarating experience and I learned a great deal from both Penny and Linda's significant knowledge of art and the art quilt. Mutual respect enabled a lively collaboration in our mission to create a visually inspiring and thought-provoking exhibition.

Looking over the final selection of images I was struck by how successfully these works reveal and interpret the world we live in. References to birth, death, love and loneliness punctuate the exhibition with emotion. Stitched, pieced, torn, dyed, burned and embellished surfaces reflect both progress and decay. Whether political or poetic, humorous or grim, Quilt National 2013 is a testament to the endless possibilities inherent in the contemporary art quilt.

Penny McMorris

Although unaware of the first Quilt National (1979), I've seen every one since. I first juried Quilt National in 1987—25 years ago. So an invitation to jury the show again this year was an unexpected honor. And to cap it off I delightedly shared this honor with two good friends: Linda Colsh and Judith Content.

I found the contrast between the 1987 jurying process and this year's remarkable. In 1987 colored slides of the quilts (overall and detail) were projected onto two screens roughly 30-40 feet away. I remember discussion about how one screen was "better" than the other, and the full quilt views being switched to the "better" screen part-way through the jurying.

Back then the photo quality varied considerably. Without fail, quilts with poor photos were judged lower. The feeling was then (and still is) that poor

photos indicated a lack of professionalism. In general, if we could not see a quilt clearly enough to judge it fairly, it was not accepted.

1987 was the first year that computers tallied judges' scores. I vividly remember how, after each jurying round, Marvin Fletcher would gather the scores, disappear for 20 minutes or more, then rush back with the results and slides of quilts remaining for the next jurying round. The "Best of Show" that year went to Susan Shie (also exhibiting in this year's show) for one of the first quilts I recall being made with such a mixed media foundation.

By this 2012 jurying, Quilt National and technology had naturally moved on dramatically (as had image quality). Jurors considered quilts independently for the first jurying round this year. We all viewed and rated not slides but digital quilt images, not together,

but at home on our own computers, using the online application SlideRoom. The rating scale: 1 = I do not want to see this quilt again; 2 = I want to see this piece again; 3 = I really want to see this piece again; 4 = I think this piece belongs in the show.

We had one week to consider 851 submitted quilts, with no email discussion between us. My first round took approximately 12 hours, working in 7 sessions, just to get through the quilts once. Looking at these quilts was a humbling responsibility. I was keenly aware that every submitted quilt represented countless hours of thought, physical work, and hopes for a happy outcome. But only 20 quilts got a 4 from me this initial round.

Was this new "independent-first-round" system fairer than the old method? I definitely think so. Significantly, we could now study each work intently, at our own speed. And we could, (and did!) zoom into details and pan around to see so clearly we could even read words on embellishments. So, too, we could choose to see size (so important in judging scale), materials, embellishment descriptions, and other pertinent information. Overall I was impressed by the crisp, clear quality of almost all submitted images, and pleased to see actual close-up details, not merely crops from the full-size image.

Round two brought all jurors together in Athens. We saw details and full views of quilts surviving round one displayed directly in front of us on large monitors, placed so close we could reach out and touch them. We again assigned numbers from 1-4, without discussion. This joint rating was tallied quickly by computer (and yes, Marvin was still involved as were many others who handled tallying efficiently), and those quilts ranking above a certain average made it into round three. We kept going in this manner, now with discussion, until we had eliminated all but enough for the show. Then we chose prizewinners.

And now you see our choices. What were we looking for? I was looking for the best art I could find. I wanted to see something new—designs or techniques that looked fresh; not repeats of popular trends. I looked for compositions that worked beautifully, that would not be stronger with additions or deletions; memorable images that made me want to look repeatedly and appeared better each time. I wanted pieces to puzzle, provoke, or surprise me, or provide a new way of looking at something familiar.

Let me try to reassure those whose work was not chosen this year. Please do not assume the worst. This would be a mistake. I know what you will never know: how close so very many of you came to being selected. What was it that pushed our decisions one way or another? Perhaps another work was similar to yours in some way, and we felt the other carried the idea, image or technique off better. But had that work not been submitted, yours might be in the show. In several cases, we would have selected your piece had it been larger. Yes, there are small pieces in the show. But we felt your piece had a strong composition that would have had more impact had it been larger.

My general advice to entrants: don't study exhibited works trying to see what judges are looking for. Next QN's jury, though with different outlooks and backgrounds, will likely look for the same thing this jury did: the best art. Try not to be influenced by other artists. And one last word of advice: do not allow anyone to photograph your quilt prior to entering. Quilt National is looking for new work not displayed before. If someone posts a picture of your quilt on the internet prior to Quilt National, your work may be disqualified for the show. It happens. And it's really a shame.

My thanks to Quilt National Director, Kathleen Dawson, and the many excellent volunteers who not only hosted and helped us during jurying, but who make the exhibition possible.

JURORS' BIOS

Linda Colsh (Belgium)

An American artist residing in Everberg, Belgium, since 1990, Linda Colsh has lived in America, Asia and Europe. A lifelong artist with two degrees in Art History, she exhibits in the US and internationally. She has curated, juried and judged exhibitions throughout the world and her work is published and in collections worldwide. She is known for her images of elderly women and men. Anonymous and invisible to most others, her subjects come from the streets where she finds them. She strips away their context, and reworks them with new narratives and imagined scenarios. Her process is weighted to designing and preparing content and cloth before the actual stitching together.

Judith Content (CA)

Judith Content has been a full time artist for more than 30 years. She focuses on shibori dyed and quilted wall pieces, as well as jewelry and landscape design. Her work is in numerous museum collections, including the Museum of Arts and Design, New York, the Fine Arts Museum, San Francisco, and the Shibori Collection, Nagoya, Japan. She has exhibited both nationally and internationally and is represented by the Jane Sauer Gallery in Santa Fe, NM. She is President Emeritus of the Studio Art Quilt Associates (SAQA).

Penny McMorris (OH)

Penny McMorris was the Corporate Art Curator for Owens-Corning Corporation for 20 years, co-authored *The Art Quilt*, and consulted on contemporary quilt shows for museums in the U.S. and Great Britain. She has an MA in Art History. Currently she is Vice President of The Electric Quilt Company.

Major support for this exhibition provided by:

The Ardis and Robert James Foundation

Nihon Vogue Co., Ltd /Japan Handi Crafts Instructors' Association

Friends of Fiber Art

Athens County Convention and Visitor's Bureau

eQuilter.com

Fairfield Processing

With additional support from the following businesses and organizations:

Hampton Inn

Honeyfork Fabrics

Nelsonville Quilt Co.

Ohio University Inn and Conference Center

Professional Art Quilt Alliance

Porter Financial Services

Studio Art Quilt Associates, Inc.

And the following generous individuals:

Betty Goodwin

Bobby and Katie Masopust

The McCarthy Family

Special thanks to:

Corrine Brown

Ron Dawson

Marvin Fletcher

Dee Fogt

Nancy Nottke

Gary J. Kirksey

Larry Hamel-Lambert

Baily Harnar and Brenna Kowall

The Quilts

Top: Lorie McCown, *My Grandmother's Dresses*
Middle: Benedicte Caneill, *Grieffiti*
Bottom: Marian Zielinski, *Goodnight, Sweet Prince*

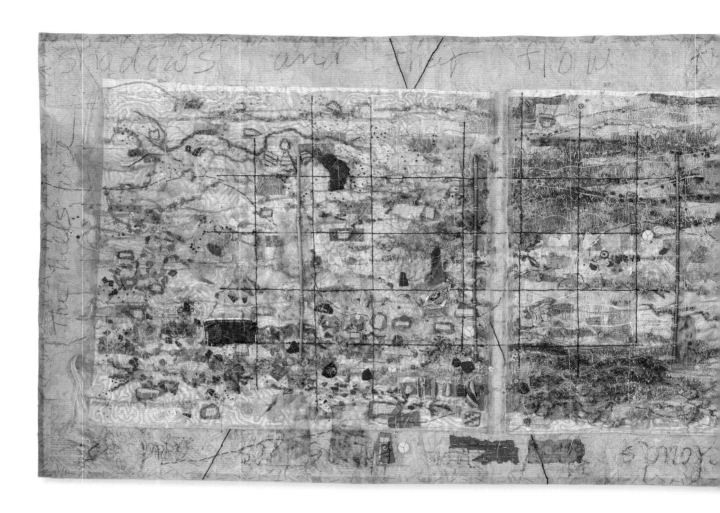

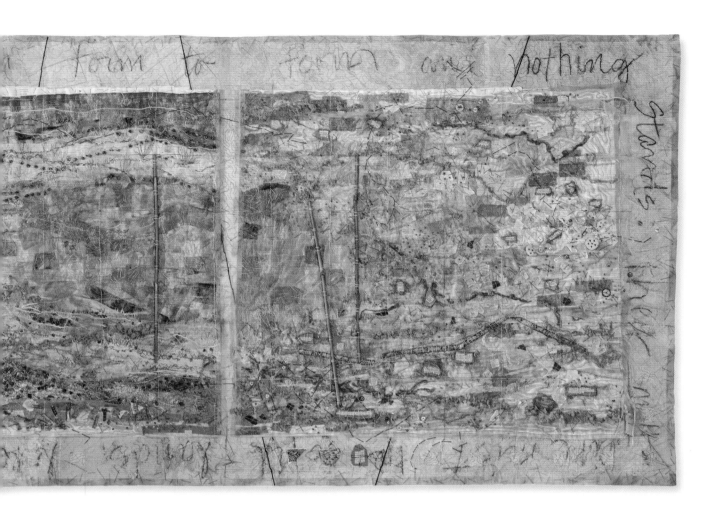

SpringField

Brooke A. Atherton

BILLINGS, MONTANA

BEST OF SHOW

2012; CANVAS BACKING, SILK ORGANZA, PAPER MAPS, COTTON, MELTED ALUMINUM, GLASS, FOUND OBJECTS; RUSTED, DYED, BURNED, LAYERED, FUSED, HAND AND MACHINE STITCHED

32"H X 97"W

"The hills are shadows, and they flow
From form to form, and nothing stands:
They melt like mist, the solid lands,
Like clouds, they shape themselves and go."

—Tennyson

A little stitching madness to hold an elusive memory.

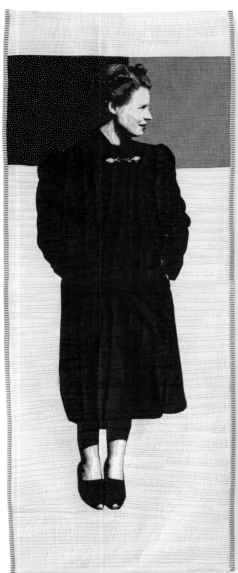

The Conversation

Mary Ann Tipple

ELYRIA, OHIO

2012; COTTON DUCK, COMMERCIAL FABRIC, PERSONAL IMAGE; PRINTED, MACHINE PIECED, MACHINE QUILTED

92"H X 72"W

This came from a photo of my dad and his sister having a conversation on the sidewalk in the late thirties. Since they are on two panels they can be switched to positions of agreement and disagreement.

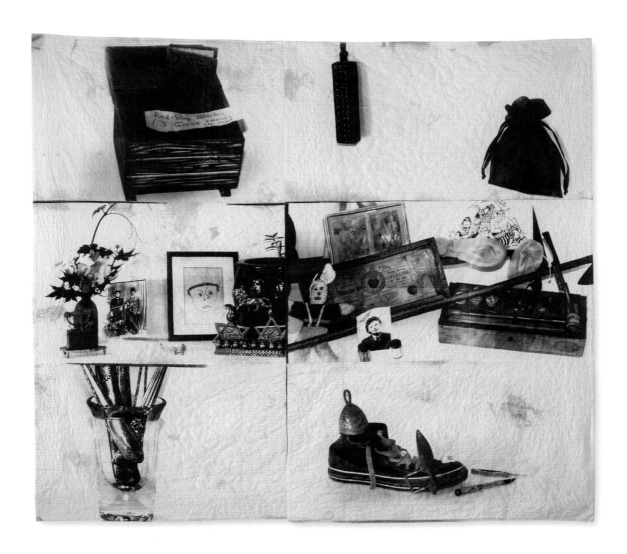

Large Regional Still Lives

Rachel Brumer
SEATTLE, WASHINGTON

2011; HAND DYED COTTON, COMMERCIAL BATTING, COMMERCIAL FABRIC FOR BACKING; DISCHARGED, HAND DYED, VAN DYKE PRINTED, MACHINE PIECED, HAND QUILTED

60"H X 72"W

Large Regional Still Lives began as a sociological study developed to think about personal objects as repositories for memories. I sent out a letter to some friends and asked if they were interested in working with me on a project to create a still life from objects that held memory and meaning. I asked them to gather objects—from nature, from family history, anything that was meaningful to them. I went to their houses, and we arranged their objects into a still life and I photographed them.

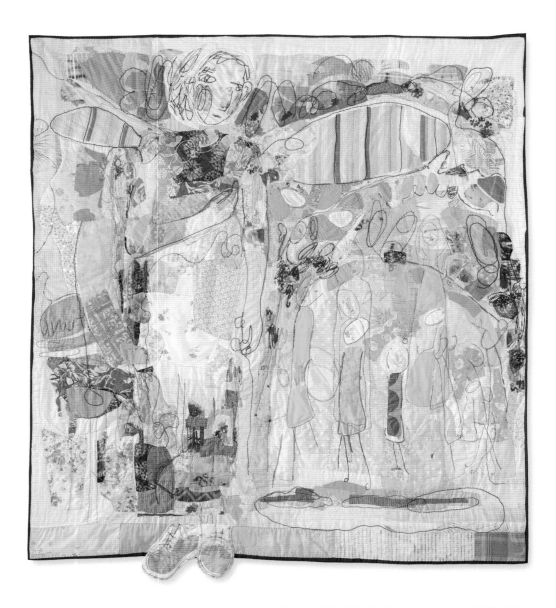

Gabriel

Anne Smith

CHESHIRE, ENGLAND

2012; RECYCLED COTTON, WOOL, THREADS, SEQUINS; HAND PIECED, HAND APPLIQUÉD, MACHINE EMBROIDERED, HAND QUILTED

72"H X 63"W

Gabriel has a job to do—he is a messenger—but what does he do on his days off from serious work? What does he wear? I wanted to let him gradually appear, through layering, stitching and drawing. Slowly, his spirit came through. Within the process of making a quilt, figures find their own identity when asked to reveal themselves.

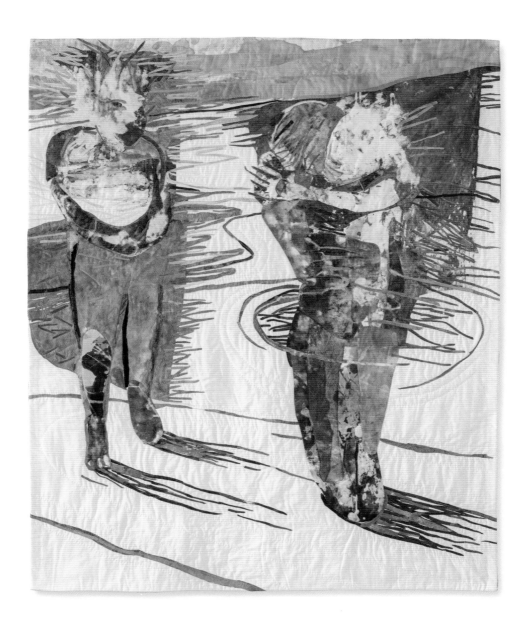

Old Child

Dinah Sargeant
NEWHALL, CALIFORNIA

2012; COTTON, FABRIC PAINT; HAND PAINTED; RAW EDGE AND
TURNED EDGE APPLIQUÉD; HAND AND MACHINE QUILTED

52"H X 43"W

Circles back to before, called by an ancient voice.

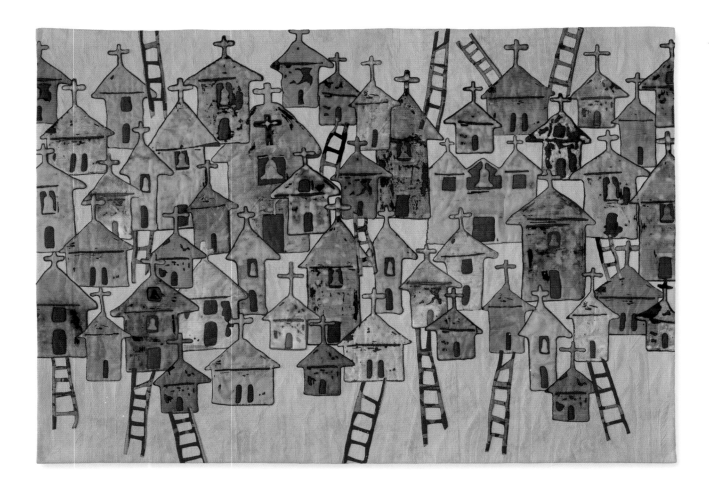

High Expectations

Mary Rowan Quinn
ALBUQUERQUE, NEW MEXICO

2012; COTTON, POLYESTER THREAD; WHOLE CLOTH, DECONSTRUCTED
SCREEN PRINT, FUSED, APPLIQUÉD, FREE-MOTION MACHINE STITCHED

39"H X 56"W

I feel privileged as an artist to share, through fiber con-
struction, my personal journey of spiritual exploration. The
symbolism in my work is that of human relationship to
supreme forces. My intention is to stitch beliefs into visual
form and allow viewers to feel peace and abundance. I
endeavor to combine color and design to create an entire
world within the confines of a limited space.

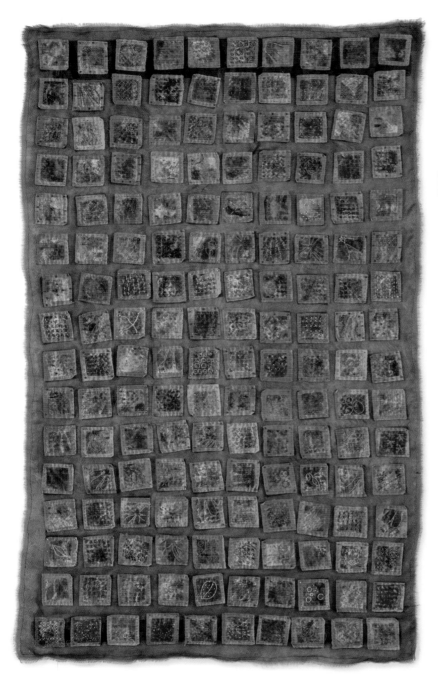

Susan Brooks

LOUISVILLE, COLORADO

Together

2012; SILK, SILK ORGANZA, COTTON, COTTON THREAD, BEADS; HAND DYED AND DISCHARGED, EMBELLISHED WITH HAND STITCHES

66"H X 39"W

My art group collaborated to dye silk banners. The process produced six of the worst pieces of fabric talented artists could make. A year later, I dreamed about unifying the silk, and calmed it by discharging color, re-dyed to unify and then tore it into tiny pieces. The process of lovingly putting the squares back together by hand stitching, embellishing, and reunifying was a gift of honoring the individuality and strength of these eight talented women.

Susan Elizabeth Cunningham

STAWELL, VICTORIA, AUSTRALIA

NetWork 1

2011; SILK; ALTERED DIGITAL IMAGES, MACHINE PIECED, MACHINE QUILTED

39"H X 67"W

NetWork 1 is a record of temporary netting around a wetland, reminiscent of a functional Christo installation. Digital images have been altered and arranged to create a fragmented pattern of idyllic, interconnected waterways, with dam banks shrouded in netting. It is an exploration between the dreamlike and the known, in the tradition of the masters. *Network 1* references some textile techniques which envelop and hold materials together, also in a functional way.

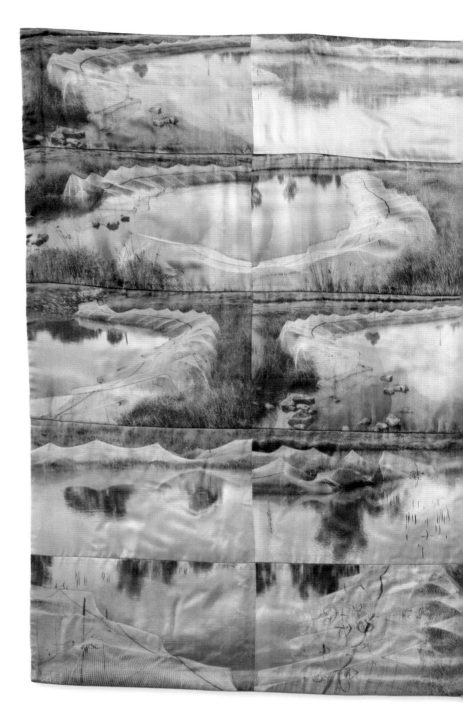

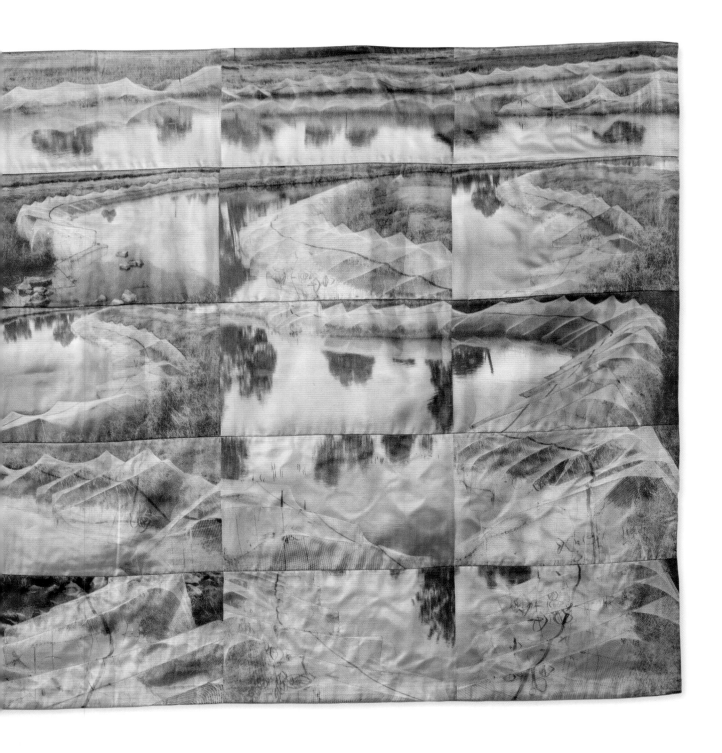

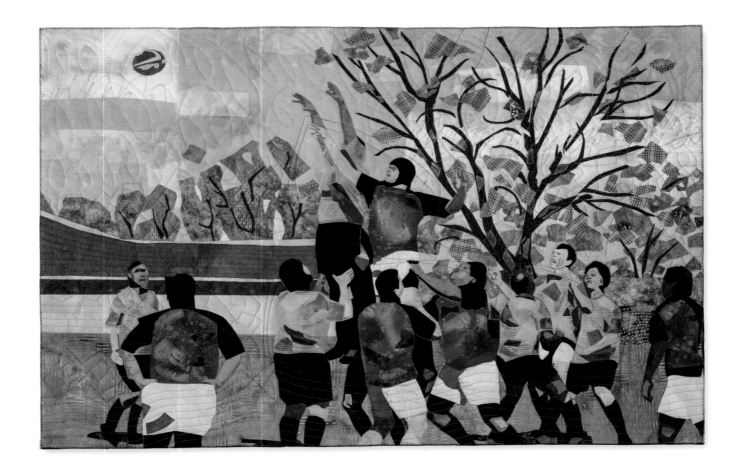

Push

Joan Sowada

GILLETTE, WYOMING

2012; COMMERCIAL AND PAINTED FABRICS, MARKERS, TEXTILE CRAYONS, THREAD, FUSIBLE WEB, BATTING; FUSED, MACHINE APPLIQUÉD, QUILTED

25"H X 38"W

I love to portray people in relationships with each other and the outdoors. Rugby is a game played in spring. I wanted to capture this invigorating juxtaposition of trees and blocks of bodies reaching for the sky.

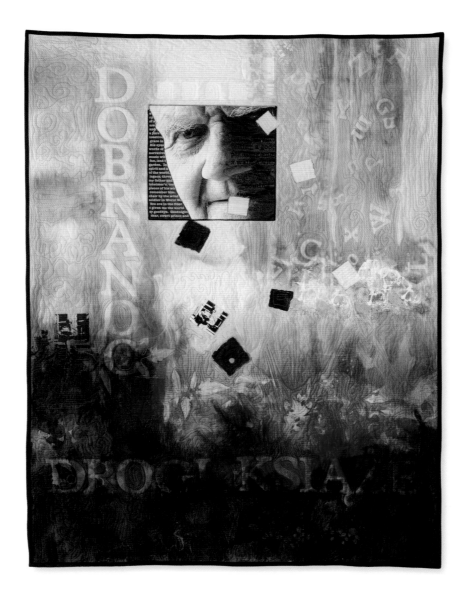

Goodnight, Sweet Prince

Marian Zielinski

MACON, GEORGIA

2012; COTTON, ARCHIVAL PRINT CANVAS, TEXTILE PAINT, TEXTILE INK, SILK DUPIONI, COTTON BATTING; WHOLE CLOTH, PAINTED, HELIOGRAPHICALLY PRINTED, SCREEN-PRINTED, DIGITALLY MANIPULATED PHOTOGRAPHY, APPLIQUÉD

59"H X 44"W

My father died from Alzheimer's disease eight years ago. For years afterwards, the ravages of the disease and the photographs I took as he gradually slipped away framed all my thoughts of him. Now, as I have reclaimed my memories of who he was in the context of the elemental energies we shared throughout our lives, I feel the power of his present absence and his absent presence, and I can finally say goodbye.

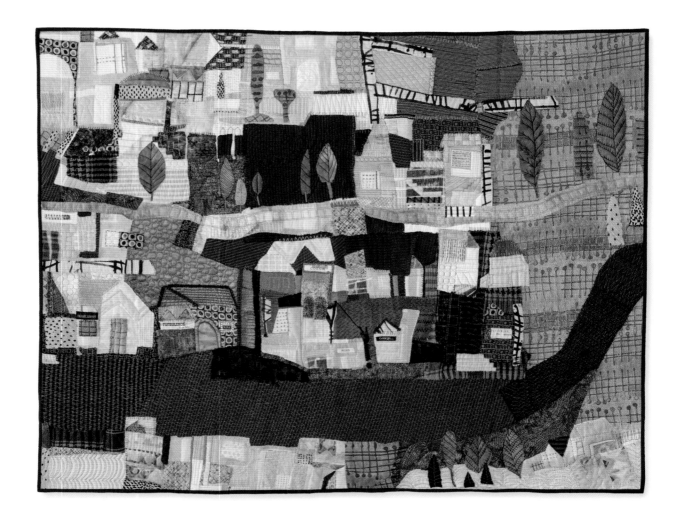

My Town by the River

Pamela Allen
KINGSTON, ONTARIO, CANADA

2012; RECYCLED AND COMMERCIAL FABRIC, POLYESTER BATTING, EMBROIDERY FLOSS; HAND RAW-EDGE APPLIQUÉD, MACHINE QUILTED

48"H X 60"W

Making art it seems to me is a pursuit of one's own voice and the personal visual vocabulary with which to express it. So often artists are hampered in their exploration by a persistent vision of the finished product. I want the work itself to direct the progress of its own development. This is the most creative aspect of art making and is a source of great pleasure for the artist and as often as not, for the viewer as well.

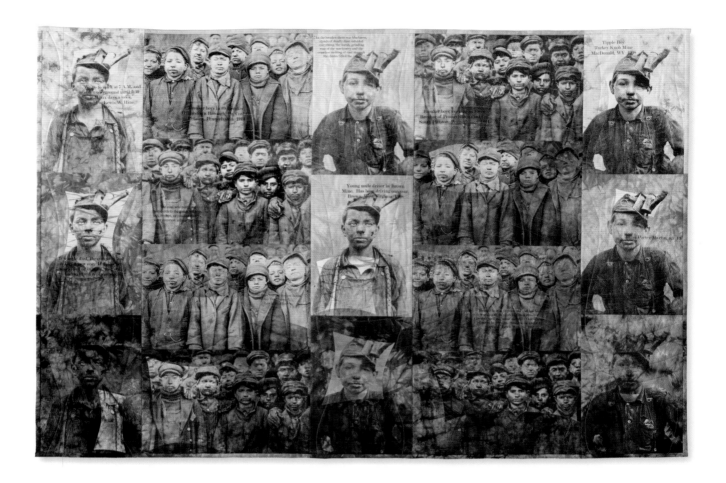

Descent Into Darkness: The Boys of the Mines

Patricia Kennedy-Zafred

MURRYSVILLE, PENNSYLVANIA

THE HEARTLAND AWARD

2012; COTTON FABRIC, FIBER REACTIVE DYES, TEXTILE INK, FUSIBLE WEB, RAYON AND COTTON THREADS, INKJET TRANSFER MATERIAL, COTTON BATTING; HAND SILK SCREENED, HAND DYED, FUSED, APPLIQUÉD, IMAGE TRANSFER; MACHINE PIECED, MACHINE QUILTED.

43"H X 63"W

My work is primarily image driven, with the intent to tell a story, trigger a memory, or elicit an emotion. The exquisite photographs of Lewis W. Hine (courtesy Library of Congress), taken in the early 1900s, have inspired me to create a series of pieces, including this quilt. I hope this work deeply touches the viewer, reminds them of someone or something they may have forgotten, or compels them to linger, just a moment longer.

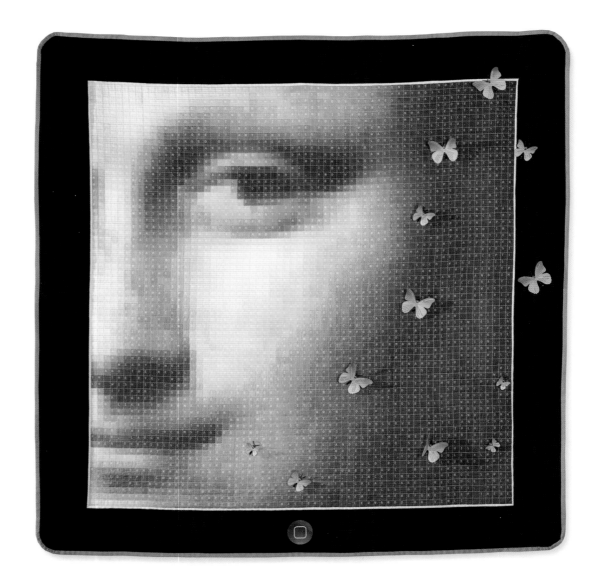

John Lefelhocz

ATHENS, OHIO

Mona in the Era of Social Butterflies

JUROR'S AWARD OF MERIT

2012; COTTON SATEEN, DA VINCI TEXT AND IMAGE DESIGNED BY ARTIST AND PRINTED BY SPOONFLOWER, BUTTERFLY EMBELLISHMENT, HAND-STITCHED

64"H X 64"W

Shifting between binary opposites and the counterbalancing that ensues interests me. Visual elements up close which are flat, transform into images that from afar become spatial. The textual characters on this work also follow this avenue; as single characters in the form of virtual keys, into words, into a series of words so that slowly a mental image is built. This, combining the past with the present, is the basis of this work.

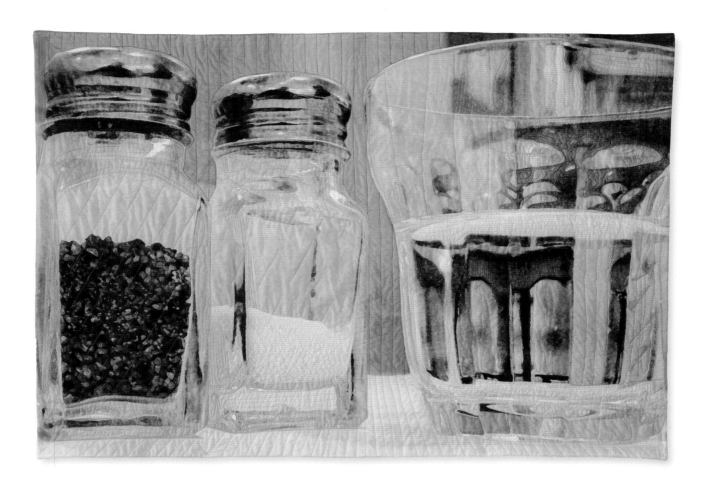

Miriam
Nathan-Roberts

BERKELEY, CALIFORNIA

JUROR'S AWARD OF MERIT

2012; COTTON, FIBER-REACTIVE DYE; PRINTED, MACHINE APPLIQUÉD, MACHINE QUILTED

40"H X56"W

In the past few years I have been exploring the marriage of digital arts with textiles. It is important to me to significantly alter the digitally printed fabric with stitching to bring out the depth in the piece. I try to pick an image that would be much more alive as a quilt than if it were printed on paper or canvas. *Salt & Pepper* came from a photograph I took in a restaurant in Seattle, Washington. The image, which I heavily manipulated in Photoshop, depicts the universal table "set-up" in cafes everywhere. Drawing on the quilt with the machine-quilting line gave me immense pleasure as I brought a dimensionality to the quilt.

Luanne Rimel

SAINT LOUIS, MISSOURI

Enigma with a Flower

2012; COTTON FLOUR SACK CLOTH, RAW SILK;
DIGITALLY PRINTED PHOTOGRAPH, PIECED,
APPLIQUÉD, HAND QUILTED

42"H X 23"W

I explore the passage of time relating to memories of the present. Images of hands and cloth frozen in stone become metaphors for memory and existence. The intersection of domestic ritual and contemporary technology interests me. I use flour-sack cloth dishtowels as the vehicle for my images, printing them with a wide format ink-jet printer. Sections are hand stitched, referencing earlier domestic practices of mending and repair, reuse and repurposing. The hand quilting creates shadows and textures alluding to the marking of time.

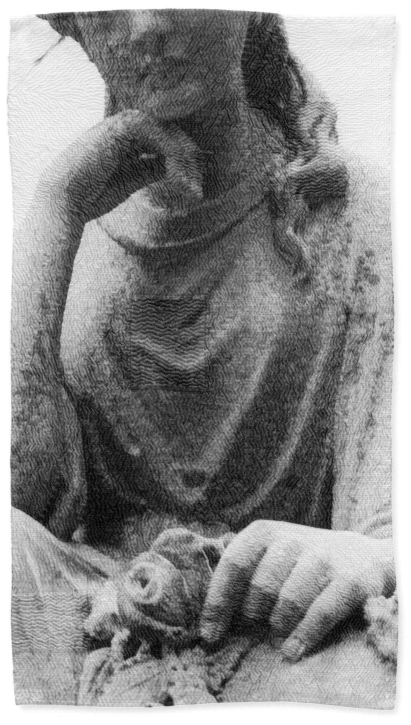

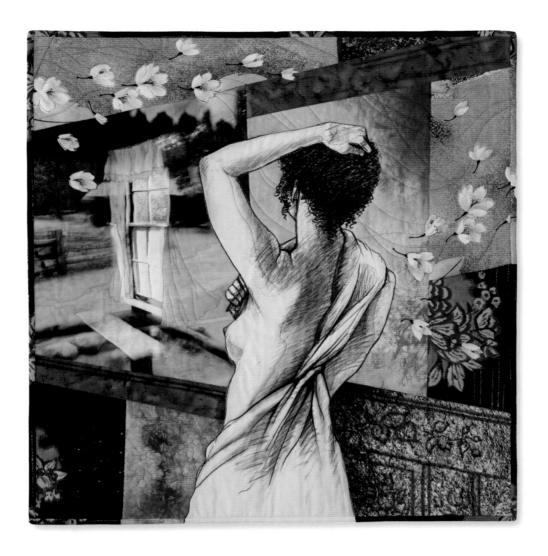

Passage

Lura Schwarz Smith

COARSEGOLD, CALIFORNIA

2012; SELF-CREATED COTTONS (DIGITALLY PRINTED BY KERBY C. SMITH AND HAND DYED BY JUDY ROBERTSON), COMMERCIAL COTTON, SILK; DIGITALLY PRINTED, DIRECTLY INKED, DRAWN, PAINTED, MACHINE PIECED, MACHINE APPLIQUÉD, MACHINE QUILTED

24"H X 23"W

A passage may refer to a journey by sea or air, a short section of music or text, a connection to a destination elsewhere, a space of time. Passage is transient by definition. I am interested in capturing one fleeting moment in that most private and solitary journey of memory: just glimpsed in passing, just guessed at.

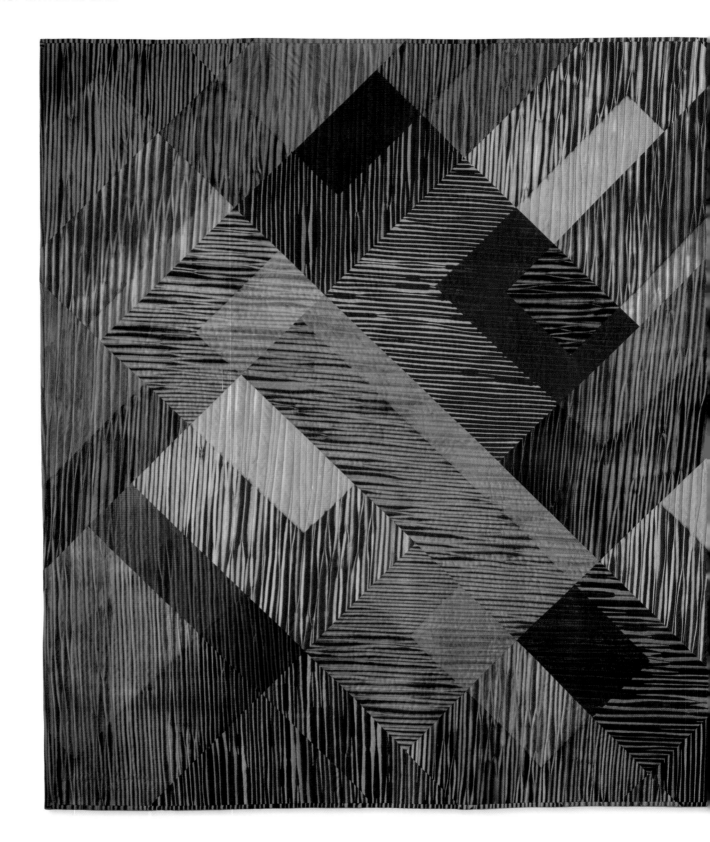

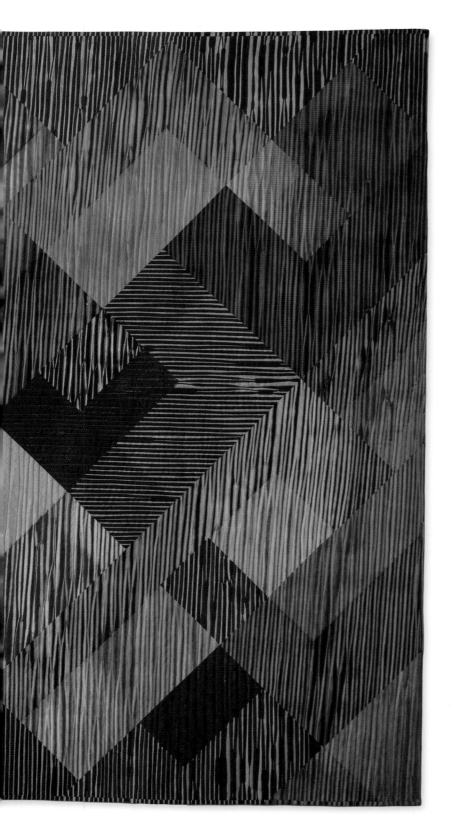

Jan Myers-Newbury

PITTSBURGH, PENNSYLVANIA

Tilt-a-Whirl

2012; COTTON, DYE, DISCHARGE, COTTON
BATTING; ARASHI SHIBORI DYED, MACHINE
PIECED, MACHINE QUILTED

63"H X 89"W

While composition continues to
be a formal matter in my work,
I am increasingly bewitched by
the serendipity of fabric, dye and,
in this instance, discharge. I have
not grown the least bit weary of
exploring the expressive potential
of color within very formal (self-
imposed) limits. The Tilt-a-Whirl
is a thrill ride, but it must remain
rooted and in balance.

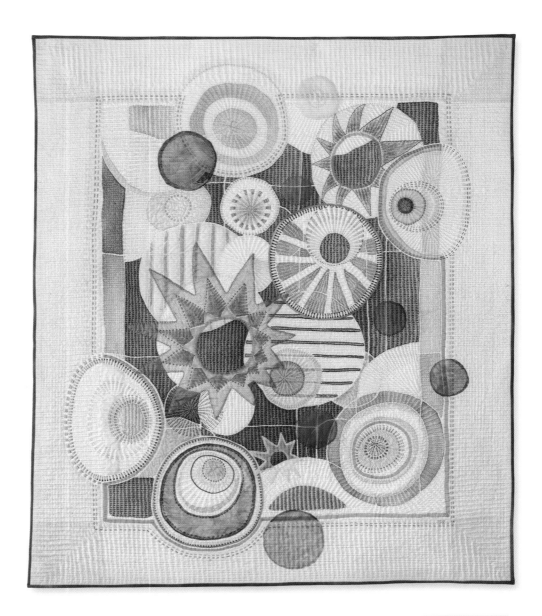

Thru the Lens

Marianne Burr

COUPEVILLE, WASHINGTON

2012; SILK, WOOL FELT BATTING, HAND DYED COTTON BACK BAND STITCHED SEPARATELY TO FELT; HAND STITCHED, RESIST PAINTED WITH SILK DYES, AND APPLIQUÉD WITH SILK ORGANZA, BACK BAND STITCHED SEPARATELY TO FELT

46"H X 39"W

Everything is so much more complex than it seems at first. Microscopes are one way to see a hidden world. When I work for many weeks to create something beautiful, I enter a hidden world of my own.

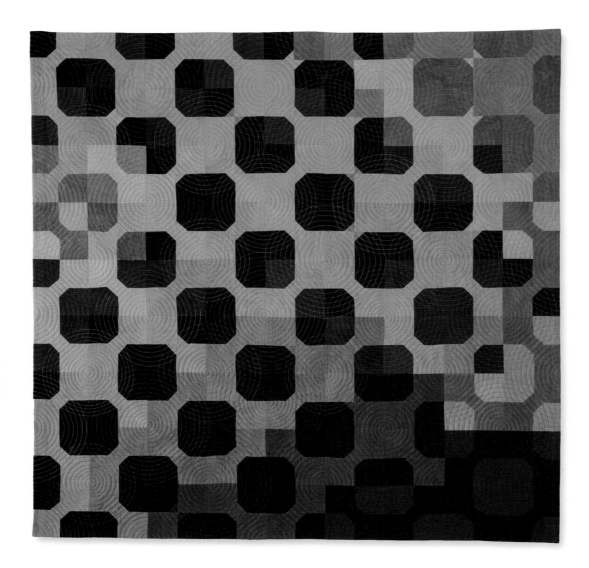

Sylvia Gegaregian

PORTOLA VALLEY, CALIFORNIA

2011; CHERRYWOOD AND OTHER COMMERCIAL HAND DYED FABRICS, 30 WEIGHT RAYON
THREAD; MACHINE PIECED, MACHINE QUILTED

53"H X 53"W

Inspired by the timeless beauty of Amish quilts, I chose the bow tie
pattern and solid fabrics I had on hand for my quest. Thus began my
journey into exploring the relationships between pattern and color
and how the interplay and placement of each can create movement
by blending one color into another to intertwine gracefully, make a
bold statement, or just fade quietly into the background.

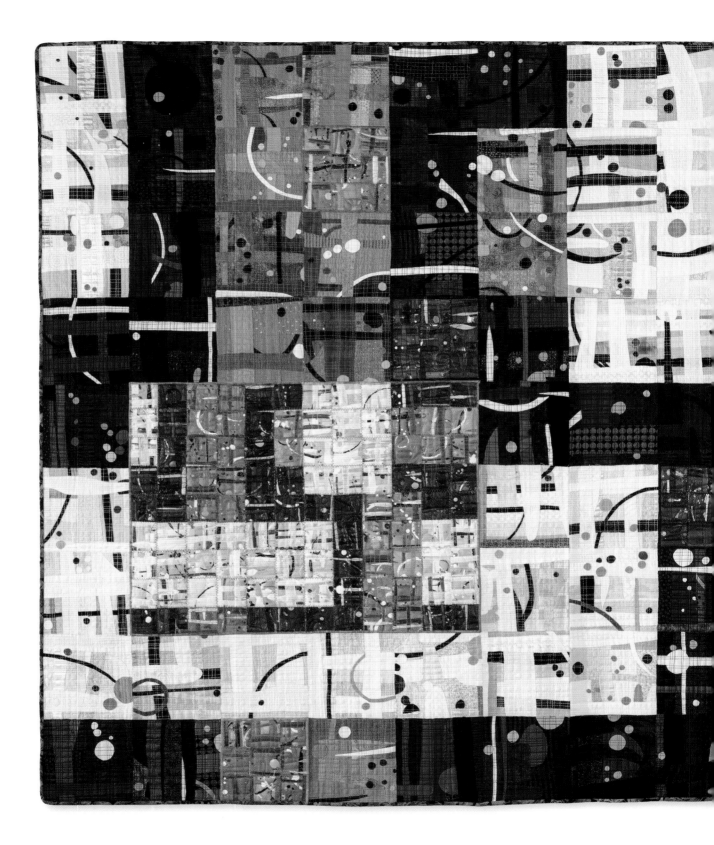

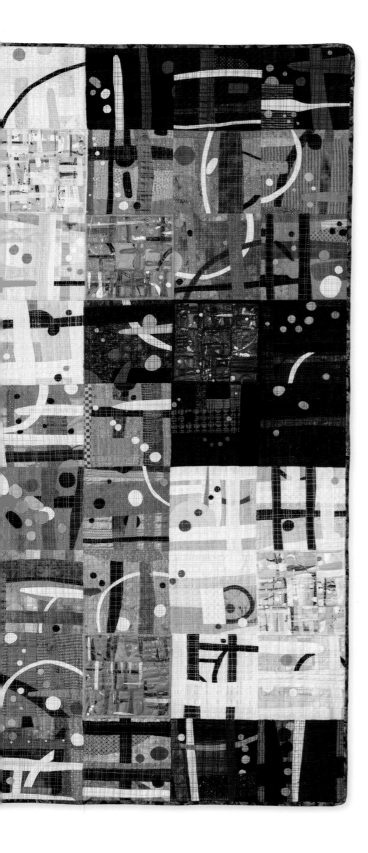

Katie Pasquini Masopust

SANTA FE, NEW MEXICO

Dolente (Sorrowfully)

2012; COTTONS, BLENDS, ULTRA SUEDE, SATIN, CANVAS, ACRYLIC PAINT, WOOL BATTING; MACHINE APPLIQUÉD, MACHINE PIECED, MACHINE QUILTED

54"H X 71"W

The emergence of *Dolente* derived from my fascination with the grid. Within a grid, I have the freedom to play with the details in a small format. The focus, at times, is on the individual components, although the overall composition is the driving force. The process of combining the quilting and painting cements this experience for me.

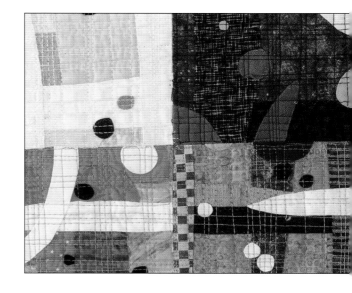

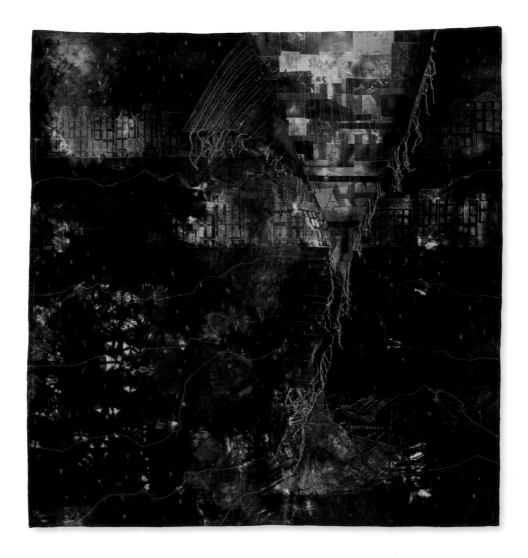

Behind the Facades

Sandra
van Velzen
TIEL, NETHERLANDS

2012; COTTON, YARN, DYE; SCREEN-PRINTED, DISCHARGED, MACHINE PIECED, MACHINE EMBROIDERED, MACHINE QUILTED.

46"H X 42"W

During the Dutch Golden Age (17th century), Amsterdam was the center of world trade. Thanks to this period Amsterdam got its beautiful canals and canal houses. However, slavery and exploitation were part of this period as well. So, what's behind all those beautiful facades and is there anything changed in the last centuries. The hand-dyed yarn at the inside symbolizes the hand painted wallpaper these canal houses used to have. The three crosses used to quilt the surface represent the crosses in the city arms of Amsterdam. I always start with white cotton, a blank canvas. I love the freedom and creative challenge of designing and creating my own quilts. I am inspired by my surroundings, everyday life or things that are bothering me.

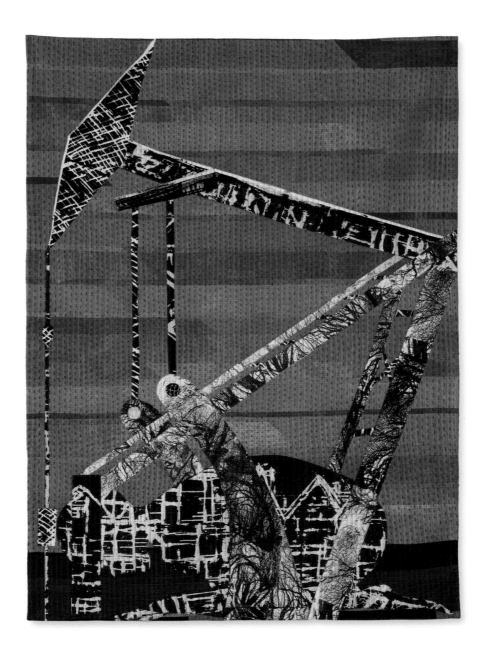

Legacy

Elizabeth Barton
ATHENS, GEORGIA

2012; COTTON; PIECED, APPLIQUÉD, DYED, SCREEN-PRINTED, HAND AND MACHINE STITCHED
62"H X 44"W

Cheap power at the cost of the environment? What is the legacy we are leaving for our children and grandchildren? A life-size child crouches to support the weight of the oil derrick. Is the stitching drops of oil—or is it the tears we are weeping for their future?

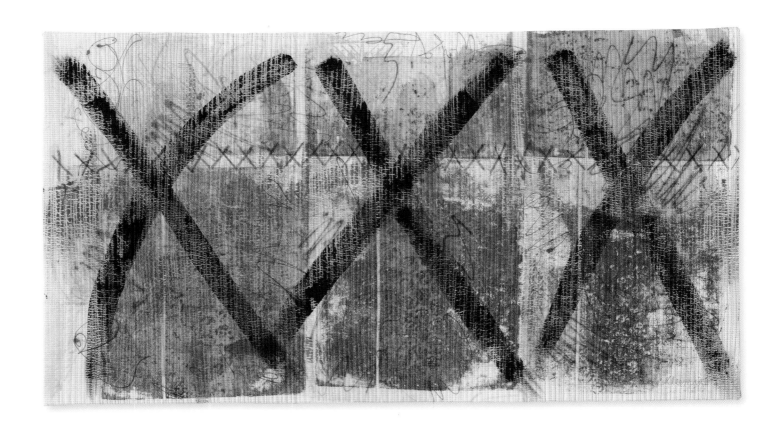

Post No Bills

Catherine Kleeman

RUXTON, MARYLAND

2012; COTTON, DYE, PAINT, FABRIC CRAYONS, COTTON BATTING, COTTON BACKING; WHOLE CLOTH, GELATIN PLATE MONO-PRINTED, PAINTED WITH CURVED TIP SYRINGE, STENCILED, MACHINE STITCHED AND QUILTED

25"H X 45"W

As I worked on this piece I was frustrated with the direction in which it seemed to be heading. I felt I had lost control of the process and that I was at the mercy of the fiber gods. Large graphic X's seemed to be the best expression of that frustration and helped me regain control. Or at least to put the piece in its place.

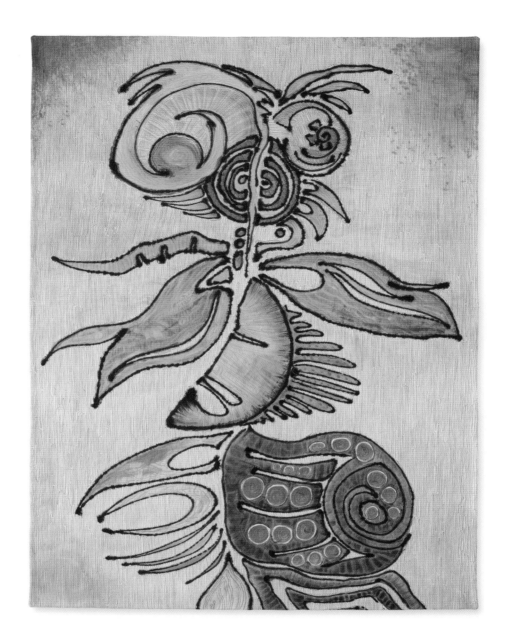

From a Seed

Sheila Frampton-Cooper

VAN NUYS, CALIFORNIA

2012; WHOLE CLOTH COTTON FABRIC, FIBER-REACTIVE DYE, PAINT STICKS; PAINTED, FREE-MOTION QUILTED

55"H X 41"W

This piece was painted spontaneously and inspired by one of my watercolor illustrations. Many of the beings I bring into form are plant-like, and they have their own personalities which come through loud and clear. She is popping out of her pod proclaiming "Here I Am!"

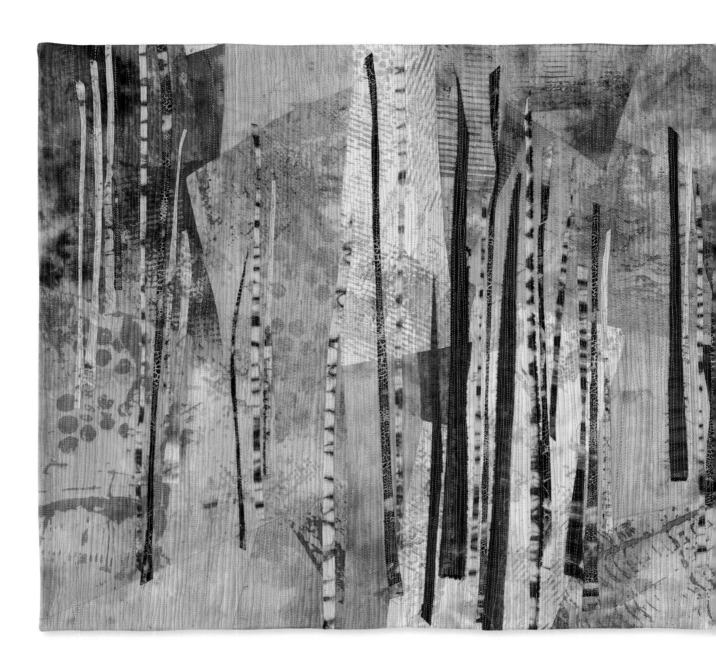

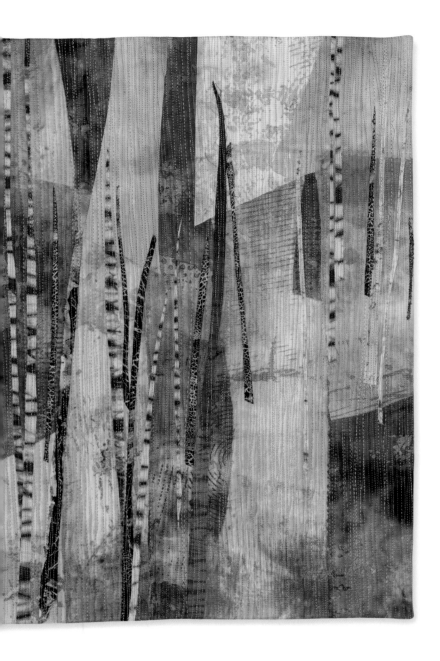

Patty Hawkins

ESTES PARK, COLORADO

Sunlit Canyon

2012; COTTON, SELF-CREATED COLORS AND
MARKINGS BY DECONSTRUCTED SCREEN
PRINT, POTATO DEXTRIN DISCHARGED
SHIBORI POLE DYED; DIRECT APPLIQUÉD,
FUSED CONSTRUCTION OF FREE-CUT SHAPES

28"H X 52"W

Sunwashed stone canyon walls
command being noticed, with
their shadow and crevice pattern-
ing. Eroded, up thrust, ancient rock
formations; skeletal white bark as-
pen motifs, and my delicious tex-
ture marked fabrics, combine for
abstract colorful shapes, informed
by nature. I espouse awareness
and responsibility for our envi-
ronment, our National Parks, and
personal surroundings.

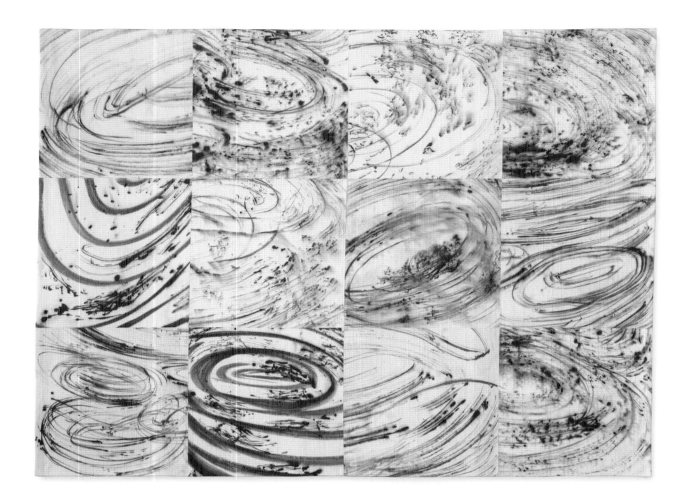

Judy Hooworth

MORISSET, NEW SOUTH WALES,
AUSTRALIA

2012; COTTON, PIGMENT INK; HAND PAINTED, MACHINE STITCHED AND
QUILTED

48"H X 64"W

...patterns of light on water...reflections and recollections...

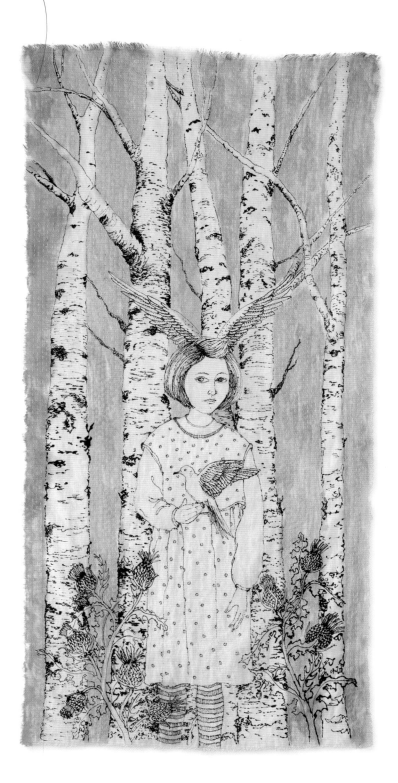

Kate Sturman Gorman

WESTERVILLE, OHIO

Bernadette In Artichokes

2012; HEMP, ACRYLIC PAINT, PERLE COTTON;
HAND DRAWN, DISCHARGED, DYED, HAND
QUILTED

60"H X 30"W

Bernadette In Artichokes is about
migration and my love of the wild
landscape of northern Michigan.
The piece is a narrative created
from personal family history. From
past to present a family migrates
along a line, my family from
Europe to the Upper Peninsula,
where my fore-bearers settled for
three generations before migrat-
ing further. After years of telling
stories with color and shape, I have
returned to line as the dominant
element.

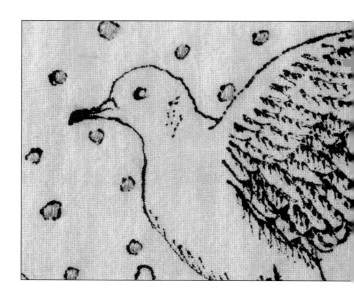

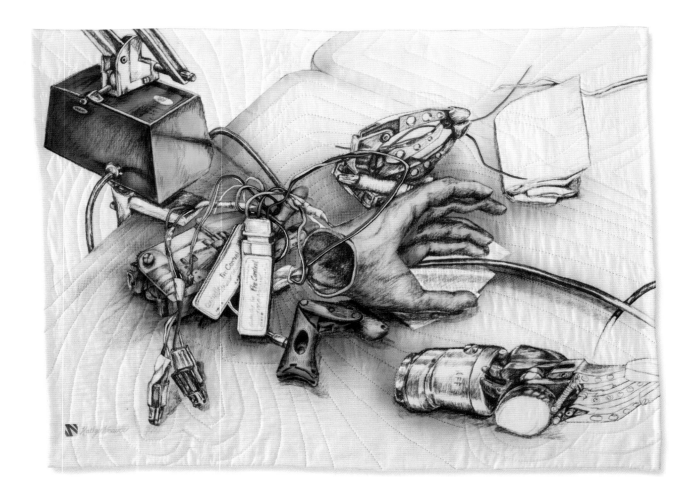

Biomechatronics Development Lab 2 v 2

Kathy Weaver

HIGHLAND PARK,
ILLINOIS

2012; ORGANIC COTTON SATEEN, ORIGINAL CHARCOAL DRAWING PRINTED BY SPOONFLOWER; AIRBRUSHED, HAND EMBROIDERED, HAND QUILTED

48"H X 53"W

Robots are the subject matter of my fiber pieces and they comment about war and its costs. After exhibiting and attending a world gathering of informatics and robotic scientists (ALIFE X, July 2006), I became interested in the integration of robotic devices and human beings.

This work results from a request I made to the Robotics Department at the Rehabilitation Institute of Chicago to draw the robots being developed to help patients with traumatic injury.

Texture Experiment #21

Dan Olfe

JULIAN, CALIFORNIA

2012; POLYESTER, POLYESTER BATTING, COTTON CANVAS BACK, COTTON THREAD; WHOLE CLOTH, COMPUTER GENERATED DESIGN, DIGITALLY PRINTED, MACHINE QUILTED

54"H X 39"W

I work at the intersection of digital art and quilt art. My quilt *Texture Experiment #21* is part of a series in which I use Photoshop to modify and layer three or more textures (photos or other images). The design for *Texture Experiment #21* was created by layering photos of the following three objects: stained concrete, weathered corrugated metal, and a rusty metal panel.

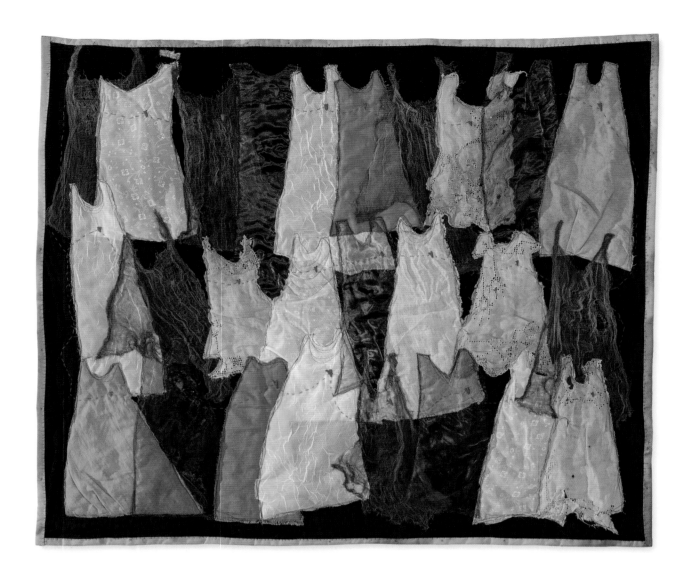

My Grandmother's Dresses

Lorie McCown
FREDERICKSBURG, VIRGINIA

2012; HAND DYED AND OVER DYED LINEN, COTTON, SILK, COMMERCIAL COTTON, SYNTHETIC FABRICS; RAW EDGE APPLIQUÉD, HAND AND MACHINE QUILTED, HAND EMBROIDERED AND EMBELLISHED

39"H X 46"W

Connected by blood or by experience, we are all part of our ancestor's stories, triumphs and failures. Some of us wear worn and tattered dresses, others of us are clothed in finery. This series is born out of a season of distress; I chose the simplest of garments to depict. I strive for narrative in my work, keeping in mind the nature of fabric and its tactile qualities and more formal elements.

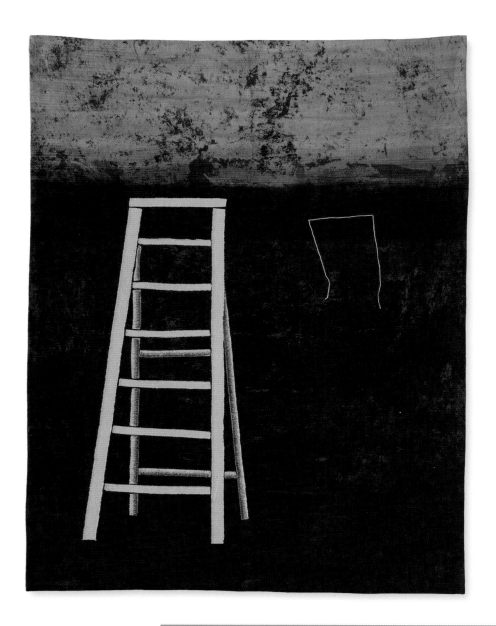

Yellow Ladder

Dale Preston Barry

SOUTHPORT, NORTH CAROLINA

2012; COTTON, COTTON BATTING, THREADS, FIBER-REACTIVE DYE, TRANSPARENT PAINTS; MONOPRINTED, PAINTED, HAND DYED, RAW EDGE APPLIQUÉD, MACHINE QUILTED, MACHINE EMBROIDERED

51"H X 39"W

Yellow Ladder is the result of an extreme makeover just weeks before the entry deadline. A heavily quilted dull and flat whole cloth quilt was transformed with a coat of transparent paint and a yellow ladder. I'm always saying, "Oh, well if I don't like it I can always paint it." This is the first quilt though.

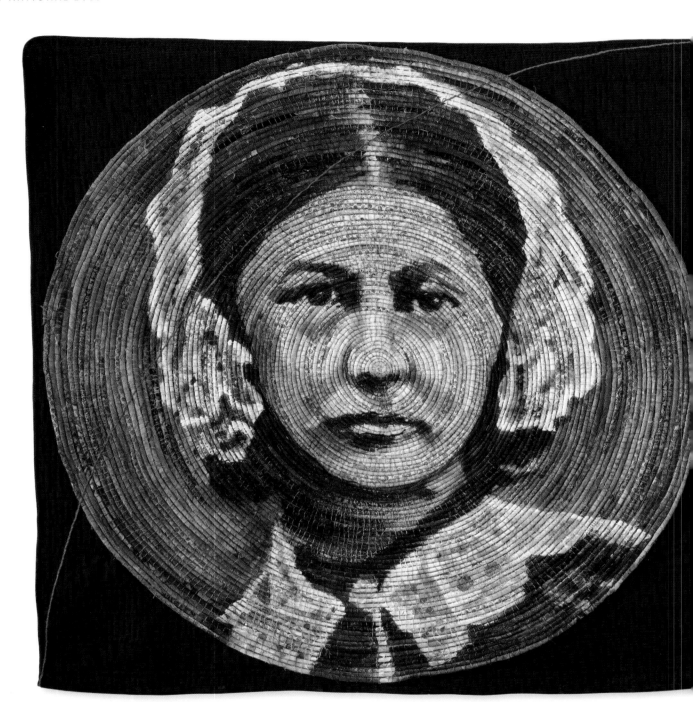

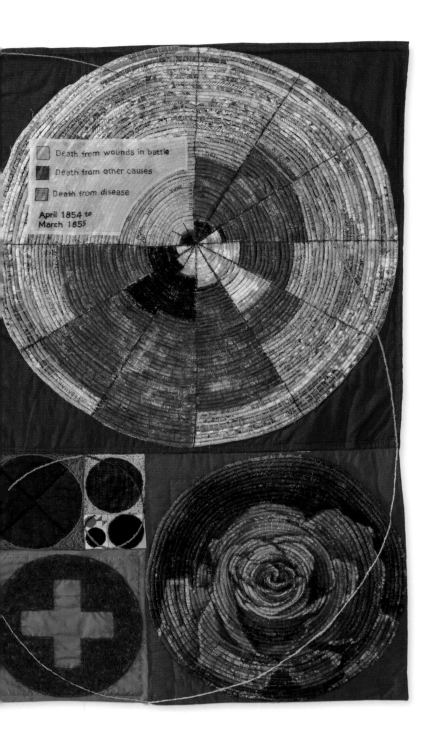

Shin-hee Chin

MCPHERSON, KANSAS

Florence Nightingale

MOST INNOVATIVE USE OF THE MEDIUM

2012; RECYCLED AND COMMERCIAL FABRICS, HEMP, ORGANZA, PEARL COTTON, RAMIE; COILED, DYED, FABRIC PAINTED, HAND STITCHED (I APPROPRIATED JI-SEUNG, KOREAN PAPERTHREAD MAKING TECHNIQUE, TO THE FABRIC AND MADE FABRIC TUBING AND COMBINED BASKETRY TECHNIQUE)

48"H X78"W

Florence Nightingale used her data to show the correlation between the cleanliness of the hospitals and the mortality rate, creating a chart, often called rose chart. In laying out her image with her rose chart, red rose, and red cross, I wished to honor her accomplishments. By synthesizing the Fibonacci Spiral, I wanted to illustrate circles and squares, math and art, beautiful mind and good deeds.

Pam RuBert

SPRINGFIELD, MISSOURI

Seattle—Wish You Were Hair

2012; COTTON, ONE BUTTON, COTTON AND
RAYON THREAD; RAW EDGE APPLIQUÉD,
FUSED, MACHINE STITCHED

65"H X 41"W

Sometimes I like a vacation from
reality. My drawings take me to
places filled with color, pattern and
humor. My quilts are like a post-
card I send back. This one is from
a city where buildings are made
from thread, and a giant woman
sits quietly threading a needle
under one of the most iconic
buildings in the world. "Wish you
were hair!"

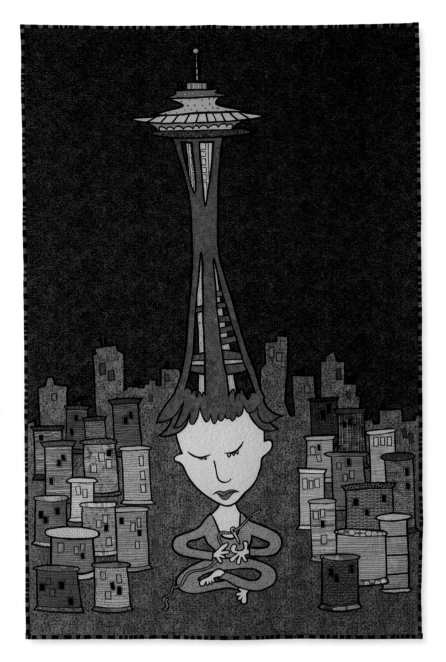

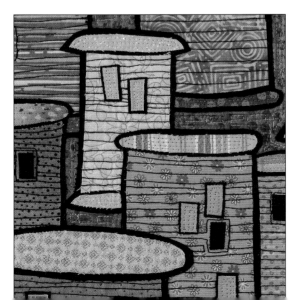

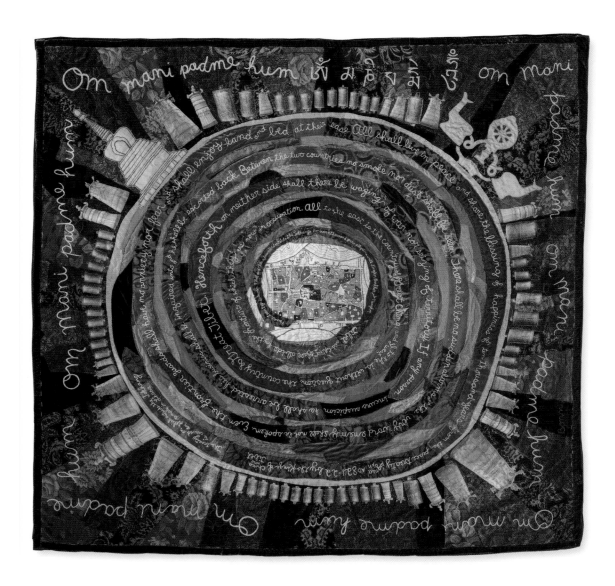

Bonnie Peterson

HOUGHTON, MICHIGAN

2012; VELVET, BROCADE, SILK; EMBROIDERED, APPLIQUÉD, PIECED, HEAT TRANSFERRED, HAND AND MACHINE STITCHED

68"H X 70"W

Upon entering the old city of Lhasa, one observes crowds of Tibetans walking through the streets. They are following a kora, a ritual clockwise route that passes through Barkhor Square and includes the Jokhang Temple. Often they twirl a small metal prayer wheel in one hand. Another ritual trail leads uphill a thousand feet above Sera and Dreprung Monasteries to small buildings clinging to cliffs marked with prayer flags and incense burning shrines.

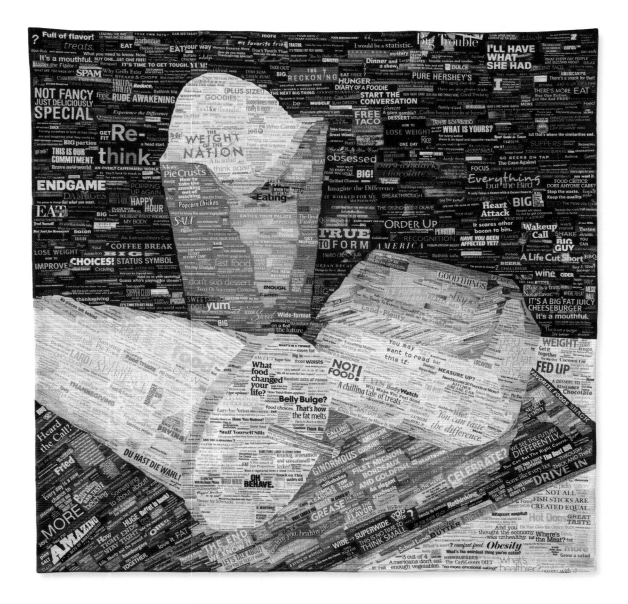

American Still Life: The Weight of the Nation

**The Pixeladies
Deb Cashatt,
Kris Sazaki**

CAMERON PARK, CALIFORNIA

2012; COTTON, GLUE, WOOL BATTING, THREAD; CUSTOM-PRINTED COTTON WORDS/PHRASES CUT FROM MAGAZINES, GLUED TO PAPER, SCANNED, PRINTED ONTO FABRIC

60"H X 60"W

We wanted to create a still life because it is a traditional art genre. However, many viewers no longer have knowledge of the allegorical language used to give still lives deeper meaning than the simple objects depicted, so we used magazine snippets to help us tell our story of the typical American diet and how it is slowly killing us. But, we admit that *we ate at the Golden Arches while plotting out our design!*

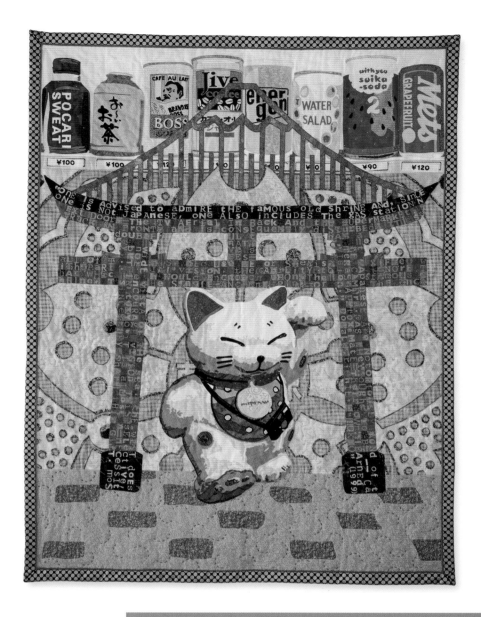

Jive Boss Sweat

Robin Schwalb

BROOKLYN, NEW YORK

2012; COTTON, FABRIC PAINT, EMBROIDERY FLOSS; MACHINE PIECED, FUSED, MACHINE AND HAND APPLIQUÉD, REVERSE APPLIQUÉD, STENCILED, HAND EMBROIDERED, HAND QUILTED

63"H X 48"W

It's a pleasure and a puzzle to experience firsthand how contemporary Japanese culture is layered over the bedrock of ancient traditions. A beckoning cat—a bit of Tokyo street architecture—is shown against a manhole cover with a cherry blossom and gingko design. The cat strides through a torii gate onto the moss and stones of my favorite Zen garden. And, there's always a vending machine nearby, offering both refreshment and amusement—Pocari Sweat, anyone?

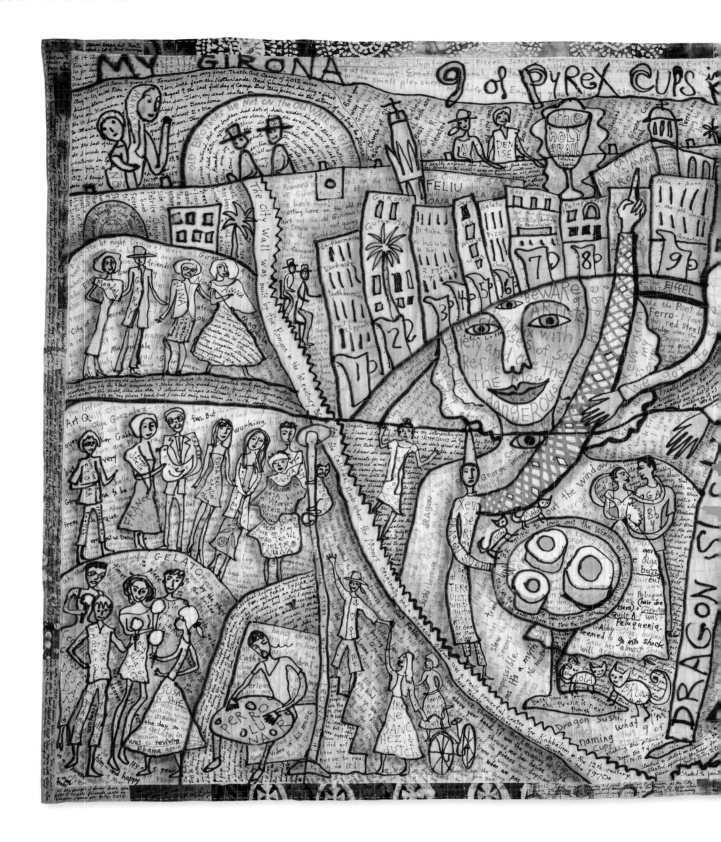

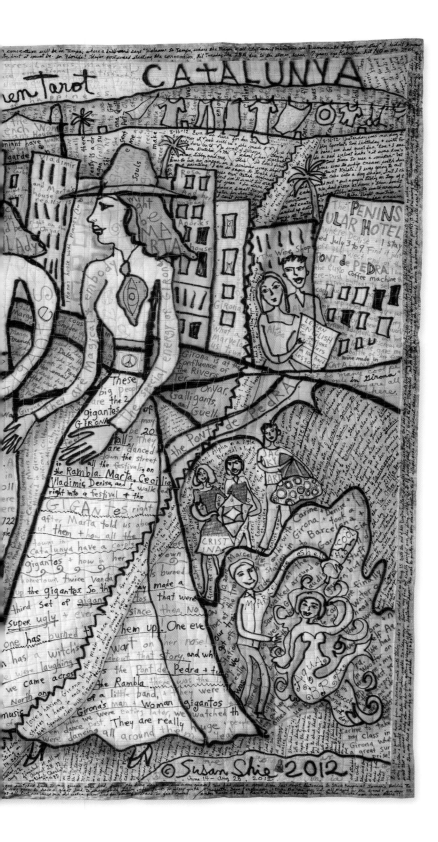

Susan Shie

WOOSTER, OHIO

Dragon Sushi: 9 of Pyrex Cups in the Kitchen Tarot

2012; COTTON, AIRBRUSH PAINT, FABRIC PAINT, AIR PEN, FABRIC MARKERS, THREAD, PERLE COTTON FLOSS, BATTING, BACKING BATIKS INCLUDE LUNN FABRICS, BUDDHA BEAD; WHOLE CLOTH, PAINTED, WRITTEN, MACHINE QUILTED

60"H X 86"W

In Girona, Spain, in July 2012, I had a solo show and taught classes at the first Interquilt Exposition. I made many sweet friends and loved the beautiful city of bridges over the Onyar River, and the ancient and mysterious Old Town, with its cathedral, church, Roman wall, and luck-giving statue of La Leona. I'm the big face in the middle, wearing a quote from Senator Joe McCarthy, about why artists are dangerous. ¡Vale! ¡Vale!

Karen Rips

THOUSAND OAKS, CALIFORNIA

High Water Mark

2012; COTTON, WOOL, PAINT; DISCHARGED,
PAINTED, MACHINE STITCHED

46"H X 29"W

The tides are a compelling force in
our world. This same powerful en-
ergy that causes the oceans to rise
and fall also influences our moods
and cycles.

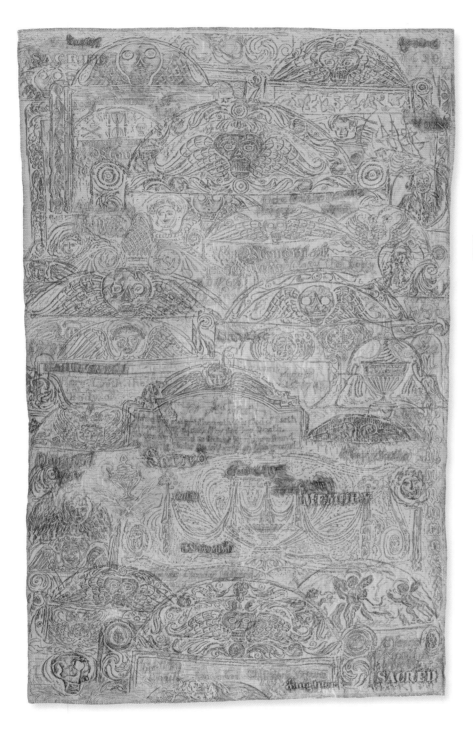

Susan Lenz

COLUMBIA, SOUTH CAROLINA

Circular Churchyard

2012; SILK, CRAYON; WHOLE
CLOTH QUILT, CRAYON GRAVE
RUBBING, FREE-MOTION MACHINE
EMBROIDERED

86"H X 53"W

Circular Churchyard explores personal and universal mortality. It investigates the concept of remembrance, legacy, and our common human frailty. The stitching outlines the passage of time through generations and points to our final future.

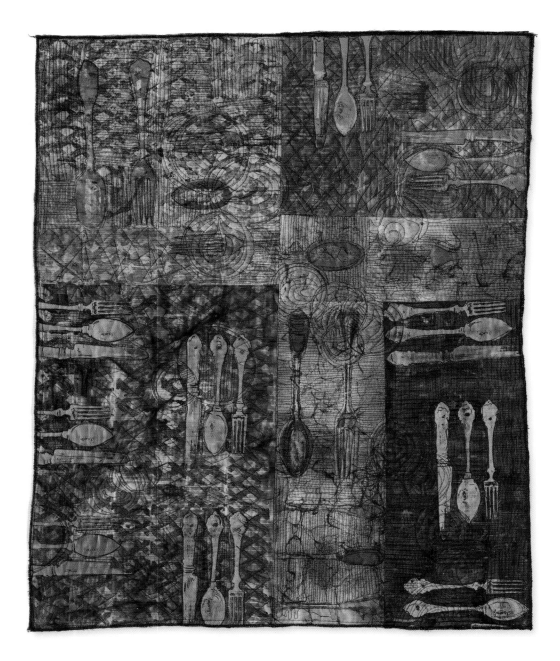

2 Top

Susan Callahan

SILVER SPRING, MARYLAND

2012; HAND DYED COTTON; HAND PAINTED AND PRINTED, MACHINE PIECED AND QUILTED

30"H X 24"W

My artwork reflects my professional life as a chef. I love the process of creating. I love that I can intersect my passion for textiles with my professional life. This piece tells the story of a restaurant table waiting for the guests. The *2 Top* is the table most available in a restaurant.

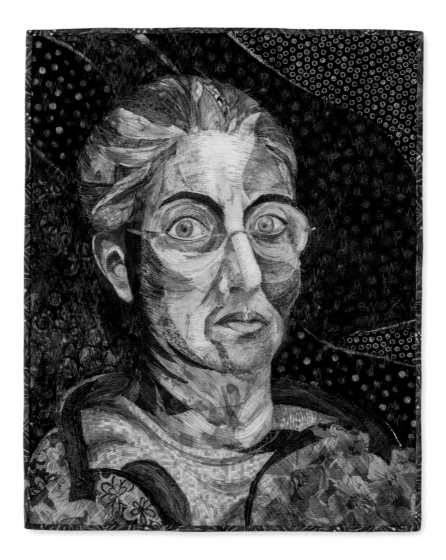

Contemplating Self

Cris Fee

LEBANON, OHIO

2012; 100% COTTON DUCK CLOTH, COMMERCIAL QUILT FABRICS, COTTON BATTING, ARTIST PASTELS, PAINT EXTENDER AND COLOR CONCENTRATES, PAINT STICKS, 100% COTTON THREAD; PASTEL DRAWN FROM LIFE, REPEATED APPLICATIONS OF FABRIC AND PAINT, PAINT STICKS, MACHINE QUILTED.

27"H X 21"W

Beginning with a live model and using fabric, paint and thread, I am attempting to find the essence of the person. By blurring the line between fabric and paint, I am trying to achieve a painterly effect within the restraints of the quilting medium. The quilting designs, and the thread colors chosen, reflect the contours of the figures form and add a ghost layer of color to the finished product.

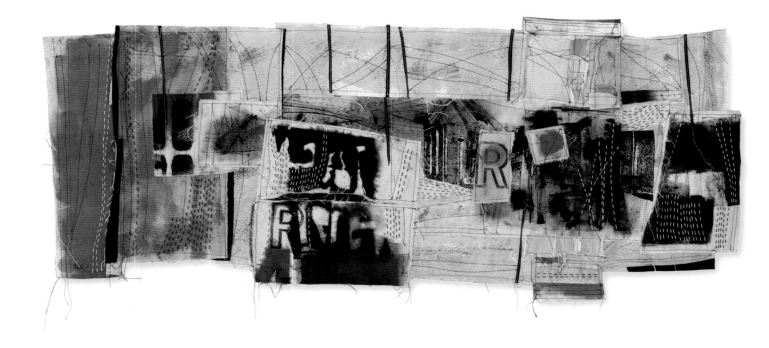

Urban Melody

Judith Plotner

GLOVERSVILLE, NEW YORK

2012; COTTON CANVAS; PAINTED, SCREEN PRINTED, STAMPED, ROLLER AND STENCILED, HAND AND MACHINE STITCHED

24"H X 56"W

The chaos of the city, graffiti, rust infused walls and peeling paint are the inspiration for my new work. My canvas is literally raw canvas and I use paint, silkscreen, stencil and monoprint to create my image. My goal is to filter my experience down to the bare essence and have the viewer interpret this essence using his or her individual receptors.

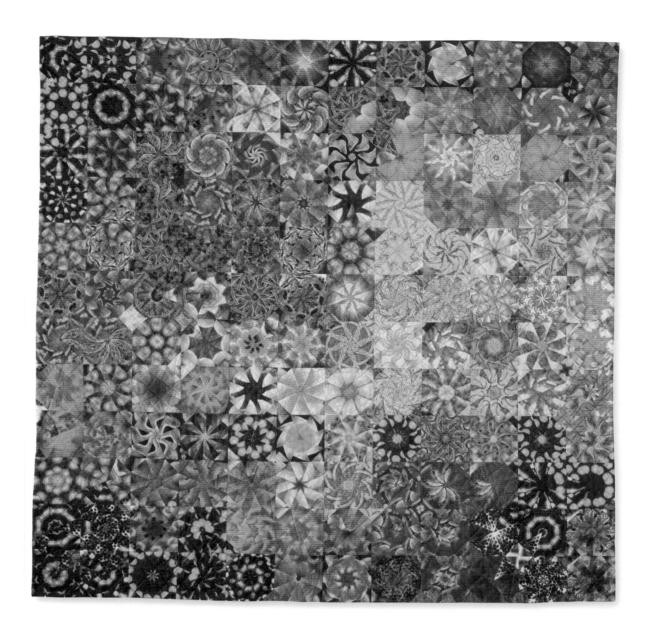

Swaddling to Shroud—Birthing Bed

Eleanor McCain

SHALIMAR, FLORIDA

2012; COTTON FABRIC, COTTON, BATTING, COTTON THREAD; FABRIC OF ARTISTS' DESIGN, PRINTED BY SPOONFLOWER; MACHINE PIECED, MACHINE QUILTED

72"H X 72"W

Kevin Womack

FOREST, VIRGINIA

From cradle to grave, beds are an integral part of life. Most of us are born in a bed. We sleep, dream, procreate, and recuperate in beds. In death, we are laid to rest. The *Swaddling to Shroud* series honors the traditional quilts and beds that hold us throughout our lives. *Birthing Bed* is the first of the series, exploring conception, pregnancy and birth.

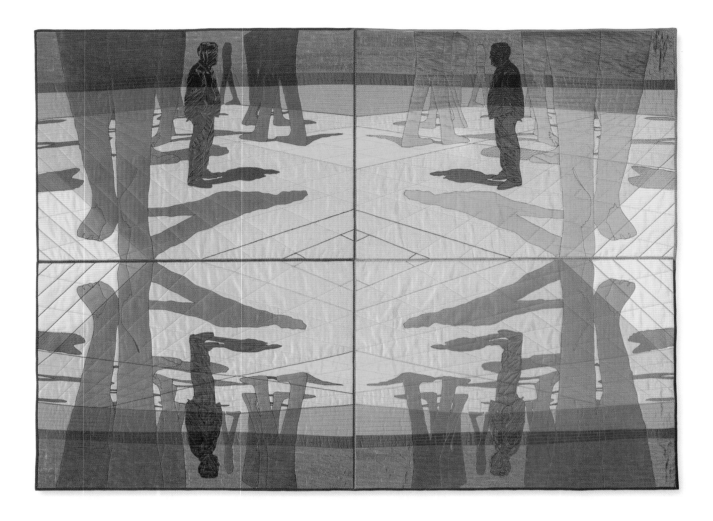

Cynthia D. Friedman
MERION STATION, PENNSYLVANIA

A Man Among Giants

2012; SILK, COTTON BATTING AND BACKING, SILK THREAD ON THE SURFACE AND LINGERIE THREAD IN THE BOBBIN; MACHINE PIECED, MACHINE QUILTED, FUSED ORGANZA OVERLAYS, MACHINE EMBROIDERED

39"H X 53"W

This piece is inspired by a photo I took in Chicago lakefront at an out-door art installation—the *Agora* giants. The 15-foot high torsos suggest human beings and cast shadows on a lovely grid concrete surface. I am fascinated with human forms and the light and shadows and how they interact with their environments.

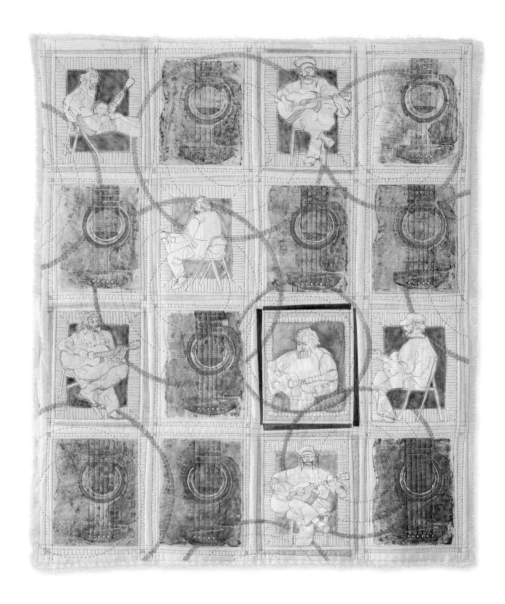

Jammin'

Laura Fogg
UKIAH, CALIFORNIA

2012; COTTON, SYNTHETIC BLENDS, PAINT, PAINT STICKS, COTTON VARIEGATED THREAD, PERLE COTTON THREAD, COTTON BATTING; FREEHAND MACHINE THREAD SKETCHED, PRINTED, MACHINE AND HAND QUILTED

53"H X 43"W

I happened to be with my sewing machine at an event featuring live musicians, and impulsively set about doing some freehand thread sketches of them as they moved around the room. I later created the guitar prints to augment the story and quilted circles to satisfy my sense of artistic design. I think my fluid process of creating this quilt reflects the lighthearted mood of these wonderful jamming musicians.

Leslie Rego

SUN VALLEY, IDAHO

Four Seasons at the Beaver Pond

2012; COTTON/SILK BLEND, HEMP/SILK
BLEND, DYES, ACRYLIC PAINT; SOY WAX
RESIST, HAND-PAINTED, LOW-IMMERSION
DYE BATH

28"H X 50"W

My work reflects the passing of
time in nature. I particularly love
the transitions between the sea-
sons, finding them to be meta-
phors for our own lives. Nature's
most beautiful moments are in
constant flux. I find the muted
browns of late autumn to be
lovely and rich, the very last faded
blooms of summer flowers to be
gentle and tender and the mud
season after the white snow has
melted to be full of promise.

Marianne R. Williamson

MIAMI, FLORIDA

Hidden Falls

2012; COTTON, KNITS, CHEESECLOTH,
VARIEGATED THREAD, WATER SOLUBLE
STABILIZER; ICE DYED, RAW EDGE APPLIQUÉD,
THREAD PAINTED, THREAD BORDER

65"H X 40"W

The ice-dyed fabric was created
to look like rocks. The challenge
was to make the falling water flow
down and around the rock with
the random pattern that water
would take. The light bounces
on the water and the droplets as
it splashes until it settles into the
pool.

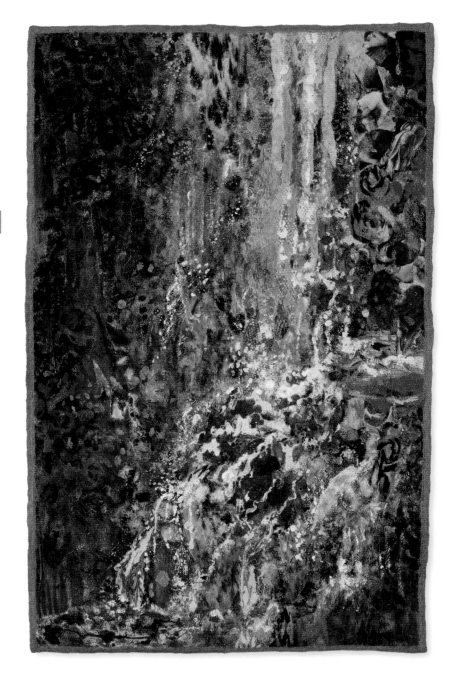

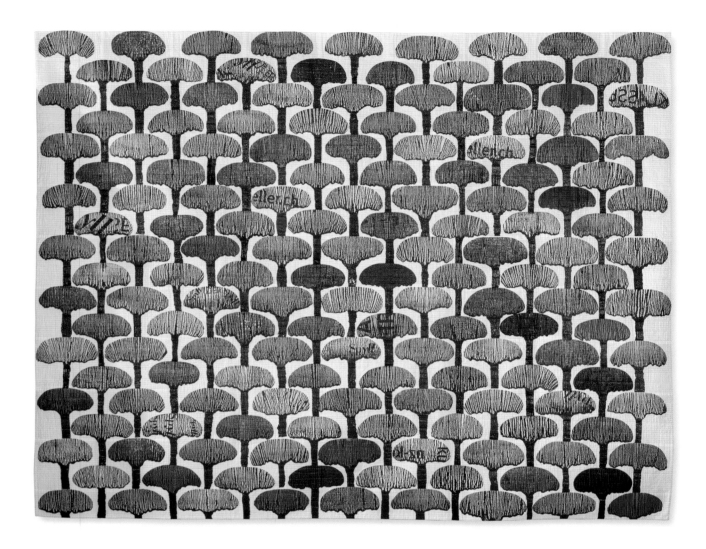

Rita Merten

SARMENSTORF, SWITZERLAND

2012; SECONDHAND AND NEW PLASTIC BAGS; FUSED, MACHINE APPLIQUÉD

65"H X 83"W

I was very impressed from the glittering colors of the sunlight in the olive groves and the structure of the olive groves of Ampolla, a little town by the Ebro Delta in Spain. The form of the trees and the structure of the olive groves was the inspiration for my work. My great pleasure is the repetition of this structure and the play with a multiple choice of the colors and the work with this incalculable material.

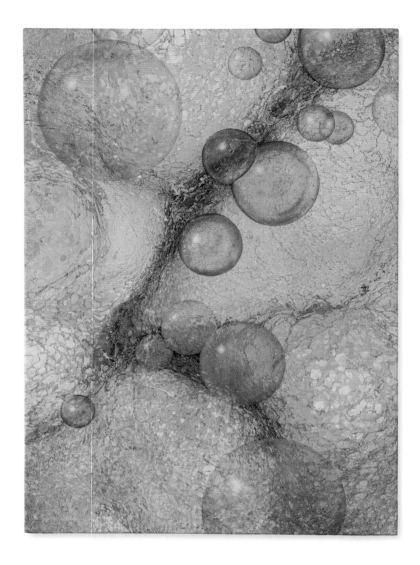

Bubbles

Karen Tunnell
ATLANTA, GEORGIA

2012; COTTON BROADCLOTH, COTTON BATTING, MUSLIN, ACRYLIC PAINT, COLORED PENCIL, OIL STICKS, COTTON THREAD; MARBLED FABRIC, HAND COLORED, HAND AND MACHINE QUILTED, TRAPUNTO QUILTED, MACHINE PIECED

42"H X 30"W

Trompe l'oeil or "fool the eye" has always fascinated me. Here my goal was to create the optical illusion of sparkling, 3-D bubbles floating off the surface of the quilt. Freezer paper stencils and oil sticks allowed me to give the bubbles a crisp translucency while marbling the fabric with a whisk. Then free-motion quilting helped mimic a textured landscape. To add the "trompe" some bubbles were trapunto quilted and some not.

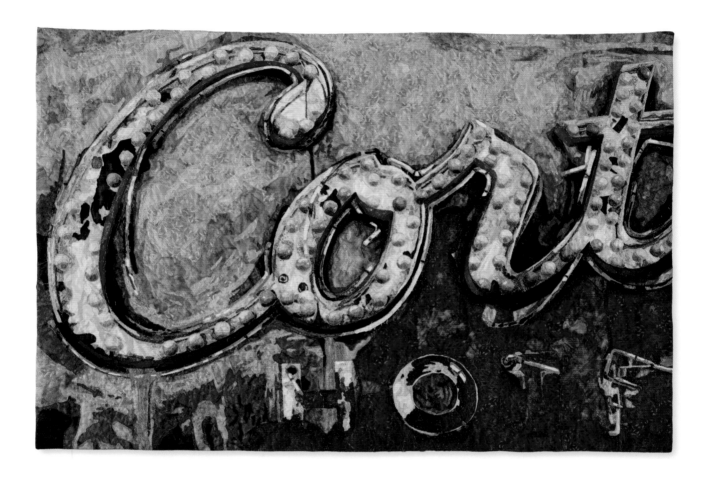

El Cortez, Las Vegas

Lisa Kijak
IRVINE, CALIFORNIA

2012; COMMERCIAL COTTON, HAND DYED FABRIC, TULLE, THREAD; RAW EDGE APPLIQUÉD, MACHINE QUILTED

38"H X 56"W

My neon series examines the passage of time as it is reflected in the worn patinas, cracks and scratches of old signs. The layered and stitched fabrics mimic the peeling paint and chipped surfaces of items left to deteriorate. This hotel sign is part of the Neon Boneyard collection at the Las Vegas Museum. While the sign has been saved from destruction, it continues to fade under the desert sun.

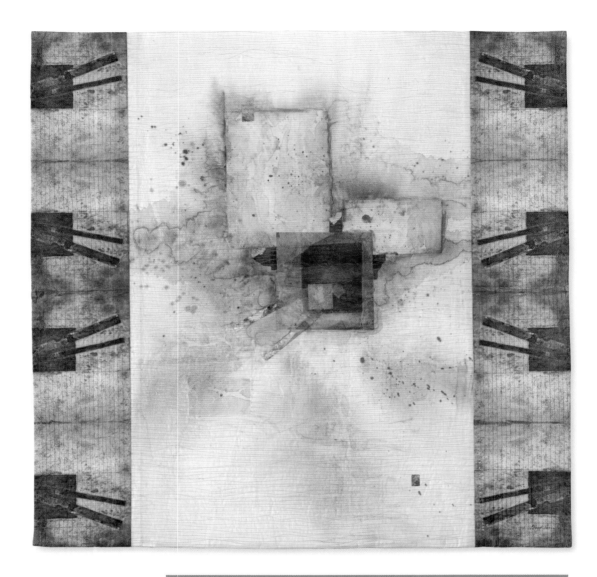

Soliloquy II

Peggy Brown

NASHVILLE, INDIANA

2012; SILK, ARCHIVAL PAPER, TRANSPARENT WATERCOLOR PAINT, DIGITAL TRANSFERS FROM ARTIST'S ORIGINAL PAINTING; HAND PAINTED, INKJET PRINTED, MACHINE QUILTED; PRINTED PAPER COLLAGE TREATED WITH ACRYLIC MEDIUM

40"H X 40"W

I approach my art quilts from the viewpoint of a watercolor artist using the same medium and methods I have used for years when painting on paper. My goal is to take a free-flowing start, and using collage, overlays of more paint and drawing, compose a well-designed finish.

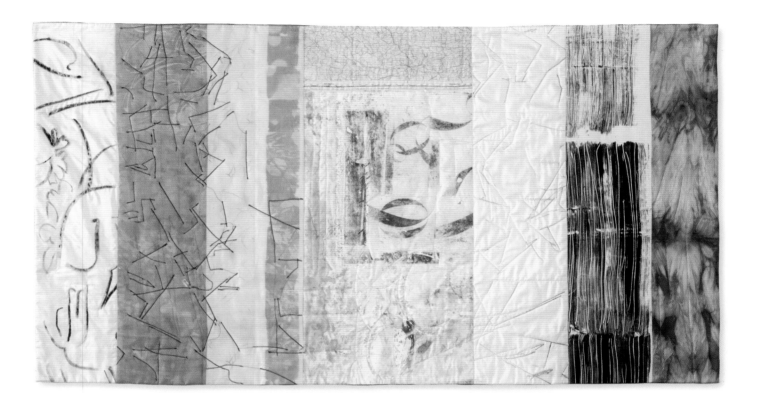

8 Meditations

Joan Schulze
SUNNYVALE, CALIFORNIA

2012; SILK, PAPER, COTTON; DIRECT PRINTED, GLUE TRANSFERRED, METAL LEAF, MACHINE EMBROIDERED, MACHINE QUILTED, CHARCOAL DRAWN, DYED, PIECED

30"H X 55"W

What fascinates me about making quilts are the layers, both physical & metaphorical. Excavating to reveal what is underneath explores another dimension. Each layer could be a separate entity but together they make a more complicated story.

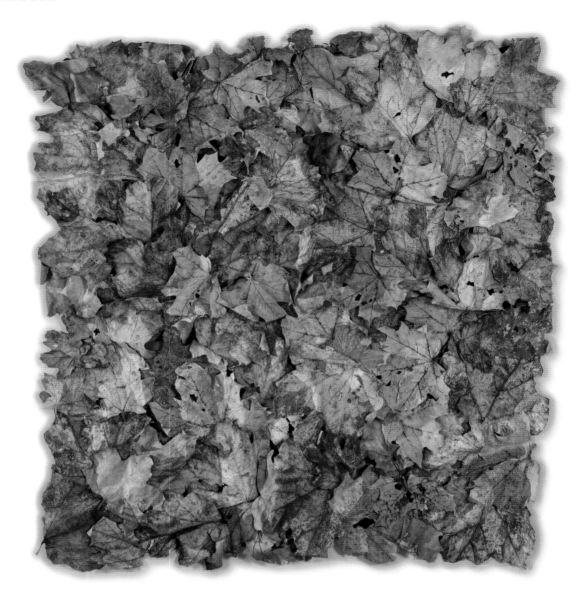

Forest Floor, var. 2

Barbara J. Schneider

WOODSTOCK, ILLINOIS

2012; COTTON, BATTING, THREAD, STIFFENING SPRAY, FUSIBLE WEB; DIGITALLY PRINTED ENHANCED LEAVES, ENLARGED, BATTED AND BACKED, FREE-MOTION STITCHED, SHAPED, STIFFENED

72"H X 72"W

My on-going interest in the Japanese concept of wabi-sabi, finding beauty in things that are imperfect, impermanent, and incomplete is at the core of all of my artwork. My *Leaves* series is an exploration and interpretation of natural images by enlarging and reshaping them. Looking at them closely and then enlarging them allows me to see them as sculptural objects. I look at the play of light upon surfaces, and shaping the pieces introduces a new element—light and shadow interacting with the undulating surfaces.

Bella Woods

Nelda Warkentin

PHILLIPS, MAINE

2012; SILK, COTTON, LINEN, CANVAS, ACRYLIC PAINT, BATTING, COTTON THREAD; LAYERED, COLLAGED, MACHINE CONSTRUCTED AND QUILTED

60"H X 40"W

Living in rural Maine, I observe the woods daily. Nature is a strong influence for me and my work. Upon returning to my studio after having spent a winter in Mexico, "Bella Woods" was born immediately and with much energy.

Threadbare

Cynthia Corbin
WOODINVILLE, WASHINGTON

2012; COTTON, POLY BLEND, COTTON BATTING, POLYESTER THREAD; MACHINE APPLIQUÉD, MACHINE QUILTED BY LONGARM MACHINE, FABRIC "AGED" BY THE ARTIST OVER A WINTER IN MY BACK YARD

36"H X 61"W

I am captivated by weather beaten surfaces, whether it is cracked concrete, peeling paint, or stained and faded wood. The beauty of the patina of aging is built up by an item's use and exposure. So apply this to fabric. Aging leaves a history, a residue of experience.

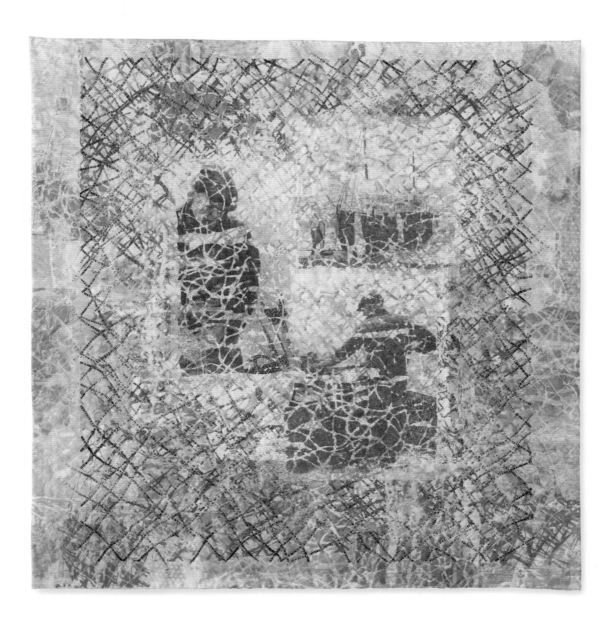

Christine Chester

EASTBOURNE, E. SUSSEX, ENGLAND

2012; POLYESTER VOILE, MUSLIN, SILK, COTTONS; PAPER LAMINATED, RUST PRINTED, MONOPRINTED, COLLAGED, HAND QUILTED

41"H X 39"W

As dementia affected my father's memories, many of the details faded but his core identity as a fisherman remained strong. The small bleeds which destroyed his recall, leaked beyond the framework of his identity, making him forget all the stories with which he amazed and delighted his family throughout our lives.

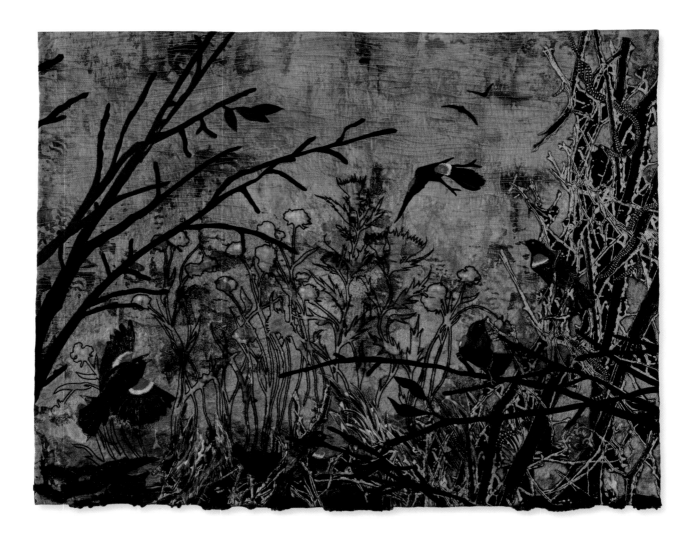

As Summer Slowly Fades...

Carol Goossens

NEW YORK, NEW YORK

2011; COMMERCIAL COTTON, SILK, ULTRA SUEDE, FAUX FUR; MACHINE APPLIQUÉD; HAND EMBROIDERED

34"H X 44"W

I love that undefinable and nostalgic feeling that accompanies a change of season. Obviously, I'm not the only one. As summer slowly fades...the red-winged blackbirds forage for food in open fields and prepare to fly south to warmer climes. Later when winter morphs back into spring, the red-winged blackbirds will return to the wetlands and I will be gripped with that unique sense of time and place, signaling a new change of season.

Beatrice Lanter

AEUGST AM ALBIS, SWITZERLAND

Blossoms

2011; POLYESTER ORGANZA, COTTON THREADS; FREESTYLE
MACHINE EMBROIDERED, CUT WITH SOLDERING IRON,
MACHINE STITCHED

80"H X 26"W

In the evening, when the mallows in my gar-
den are lighted by the setting sun, they look
especially magical. This glowing has inspired
me to realize the theme of "light-transparency-
blossoms" with textiles.

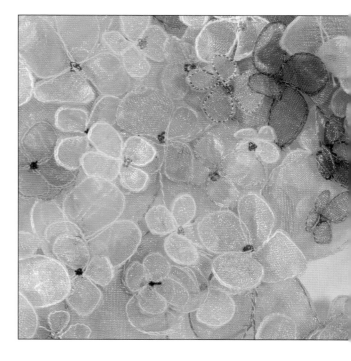

Susan V. Polansky

LEXINGTON, MASSACHUSETTS

No One But You

2012; COMMERCIAL COTTON FABRICS, FUSIBLE WEB, GLUE STICK, SILK BATTING; FABRIC COLLAGED, FUSED, MACHINE STITCHED

49"H X 65"W

The dancers were consumed by passionate intensity, despite the swirl of activity around them. Nothing but their connection mattered. From the start, the emotion appealed to me and I came to understand just how important it was while I worked on this piece. During that time, a number of people close to me passed away. The meaningful things they left were not possessions, but the moments that I had shared with them.

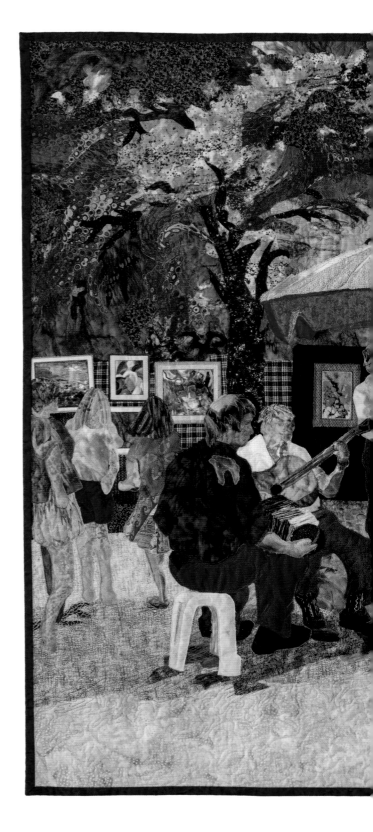

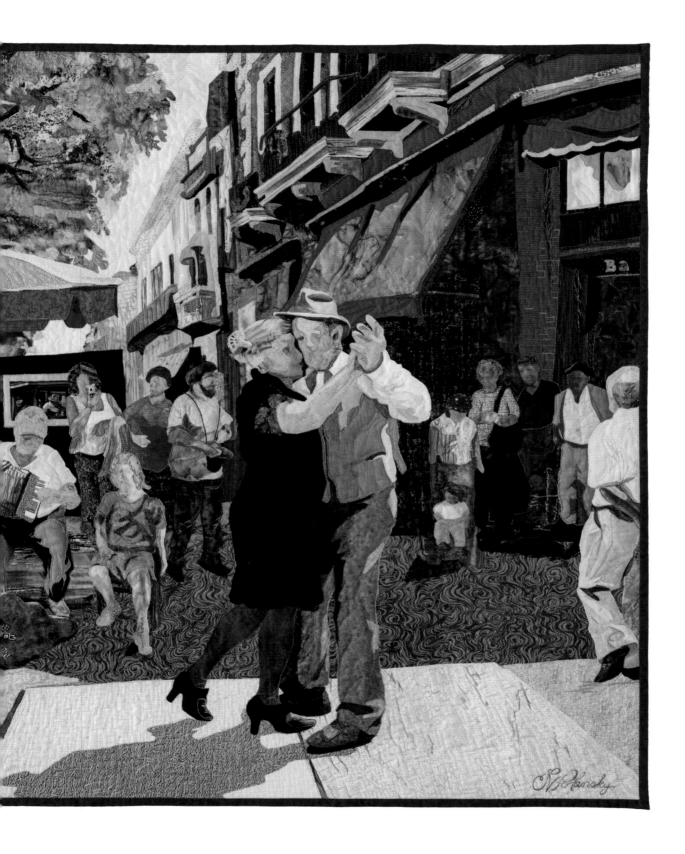

Leslie A. Hall

LONGBOAT KEY, FLORIDA

Casual Query #3

2012; HAND-DYED PIMA COTTON, PERLE
COTTON EMBROIDERY THREAD, POLYESTER
THREAD; WHOLE CLOTH QUILT, HAND
AND MACHINE QUILTED, QUESTION MARK
AND SMALL LETTERING UNDERNEATH ARE
TRAPUNTOED.

58"H X 41"W

There is no mystery to this quilt.
The content is both comical
and deadly serious. Therein lies
the rub. I felt the need to ask an
obvious question. Somehow, I
don't think there's a satisfactory
answer.

"Is it my imagination, or is having
a sense of irony in short supply
right now"

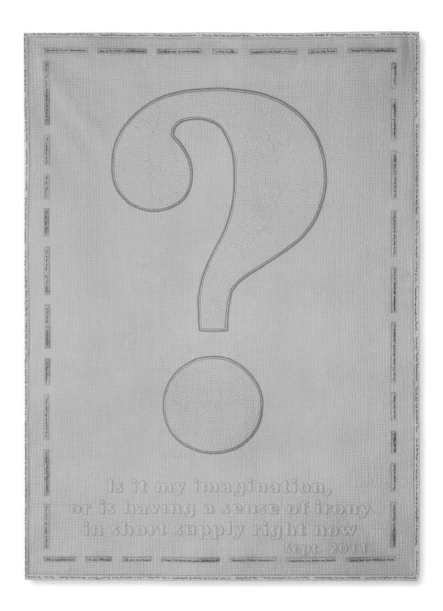

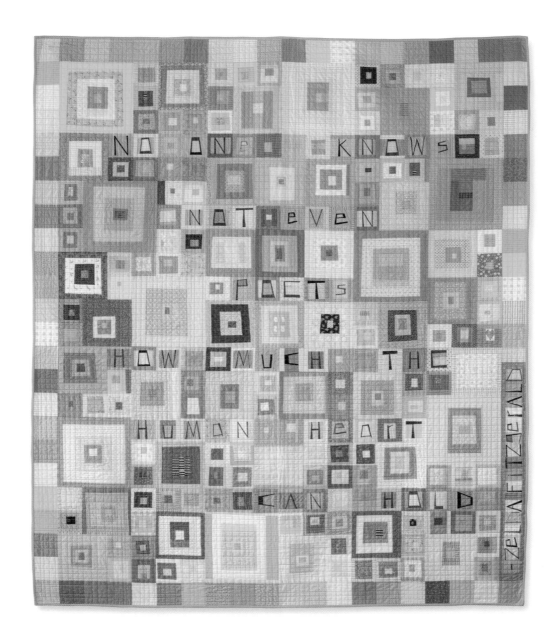

Molly Allen

BIRMINGHAM, MICHIGAN

2010; COTTON; MACHINE PIECED, MACHINE QUILTED

69"H X 58"W

Like a fabric poster, the colors, words and forms all work together to deliver the message: what is the most vulnerable can also be the most resilient.

Graffiti Series: Chain Link

Kerby C. Smith

COARSEGOLD, CALIFORNIA

2012; CANVAS, ARCHIVAL PIGMENT INK, HEAVYWEIGHT INTERFACING, COMMERCIAL COTTON BACKING, GROMMETS, METAL RINGS; WHOLE CLOTH, PRINTED, CUT, FUSED, MACHINE STITCHED

32"H X 24"W

In a hurried world, one can find great value to pause and look for beauty in the play of color, light and shadow on the mundane. Amongst the sprawl of spray paint on a wall or fence, often hidden in obscure layers lie gems of beauty.

Elin Noble

NEW BEDFORD, MASSACHUSETTS

Fugitive Pieces 11

QUILTS JAPAN PRIZE

2012; COTTON, DYE, SILK AND COTTON
THREAD; CLAMP RESIST DYED SHIBORI ON
COTTON, DISCHARGED AND DYED SEVERAL
TIMES, QUILTED BY LONGARM MACHINE
WITH HAND-DYED COTTON AND SILK
THREAD

65"H X 45"W

In the series *Fugitive Pieces*, I am
inspired by the Canadian poet,
Anne Michaels' novel of the same
name. I seek the visual equiva-
lent of her beautifully crafted
sentences, her quietly unfolding
imagery, and both subtle and
haunting stories. I believe her
range of feelings and moods can
find its equivalent in the softness
and depth of cloth, and in its tac-
tile and luminous qualities.

Benedicte Caneill

LARCHMONT, NEW YORK

Grieffiti

2012; COTTON, TEXTILE PAINTS, COTTON/
POLY BATTING, COTTON AND POLYESTER
THREADS; MONOTYPED FABRICS USING
A PLEXIGLASS PLATE, MACHINE PIECED,
MACHINE APPLIQUÉD, MACHINE QUILTED

65"H X 31"W

When does a line become a let-
ter, then a word? How can words
express overwhelming emotions?
How do you come to know your
feelings and make sense of them?
This piece deals with that mystery:
how inner feelings attempt to take
an outward form on a surface. The
words are not yet legible but thrive
towards understanding.

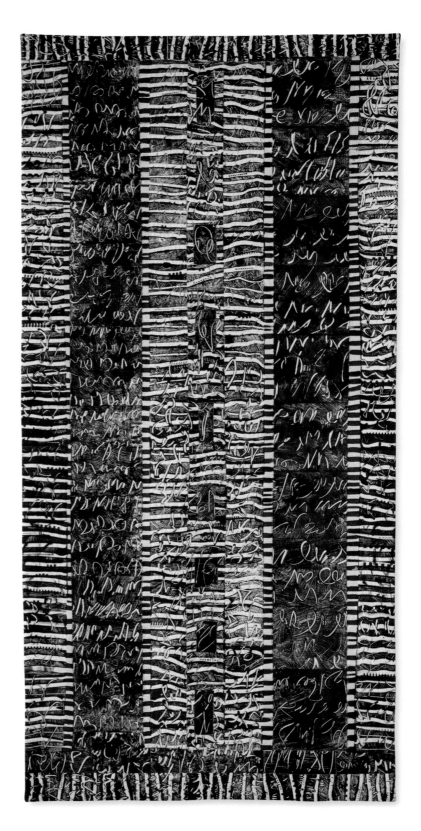

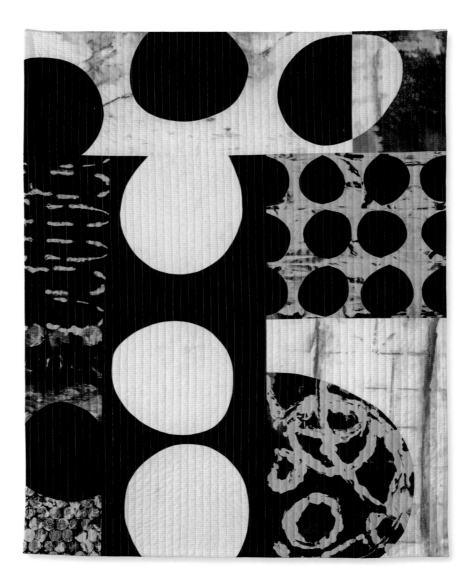

Decay

Leslie Bixel
LOS GATOS, CALIFORNIA

2011; COTTON FABRIC, COTTON THREAD, WOOL BATTING, FOUND OBJECTS: GARDEN TRELLIS, METAL STAKES, BARBED WIRE, NAILS; HAND-PAINTED, BLEACH DISCHARGED, RUST-STAINED WITH FOUND OBJECTS, MACHINE PIECED, MACHINE QUILTED

54"H X 42"W

Even though I am an abstract artist, my work is personal, and is often rooted in direct close observation of nature. Decay is part of a series of works featuring organic circular motifs. This piece began with a rusted garden trellis, and grew into an exploration of mark making using techniques that are corrosive to cloth over time. Nature is relentless, powerful, brutal, and quietly beautiful, even in the process of decomposition.

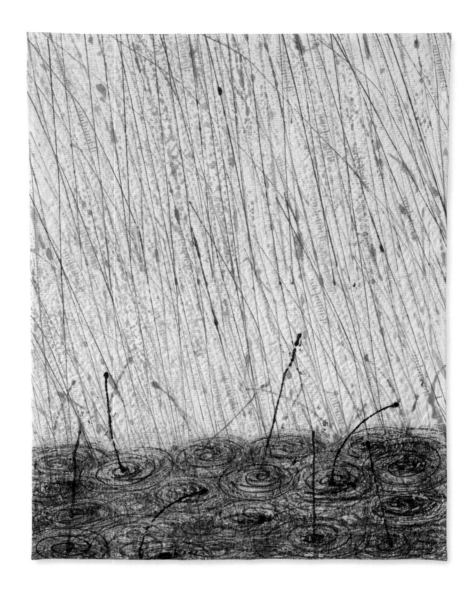

Listen to the Rhythm of the Falling Rain

Sandy Gregg

CAMBRIDGE, MASSACHUSETTS

2011; COTTON PRINT CLOTH, COTTON BATTING, COTTON BACKING, DYE; THICKENED DYE, PAINTED, SCREEN PRINTED

54"H X 41"W

I find the sound of falling rain is very soothing and brings back childhood memories. Rain is an important part of our ecosystem and the drought of the last few summers is a reminder of its importance. This piece was begun during the spring, which has been the rainiest season on the East Coast for the past few years.

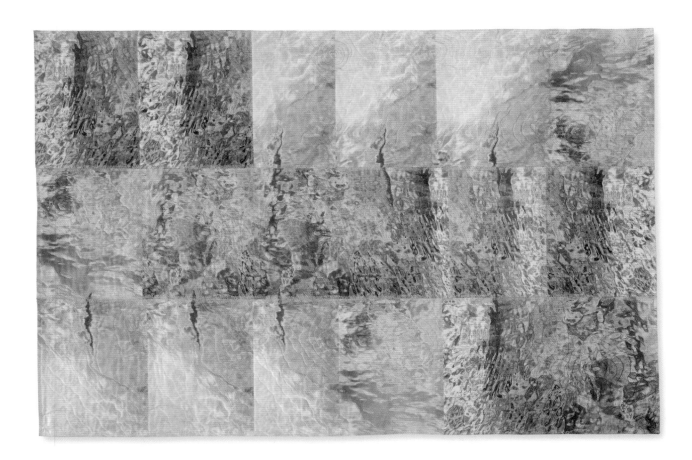

Reverberations: Yellowstone Waters

Charlotte Ziebarth

BOULDER, COLORADO

PERSISTENCE PAYS AWARD

2012; SILK, COTTON, PIGMENT INKS, COTTON AND RAYON THREADS, BATTING; DIGITALLY PRINTED, LAYERED, STITCHED

42"H X 62"W

This quilt was created from a series of photographs taken at Yellowstone's geyser basins. The distorted reflections, ripples, patterns of light and floating elements create a mesmerizing world.

The repetition of stitched lines, the patterning of grids and block arrangements, the resulting bas-relief effects of stitched, layered, quilted silk cloth allow me to tell a multi-layered story of my impressions of the experience of gazing into that world.

Dianne Firth

CANBERRA, OCEANIA, AUSTRALIA

Storm

MCCARTHY MEMORIAL AWARD

2012; VISCOSE FELT, POLYESTER NET,
POLYESTER THREAD, DYE, PASTELS; CUTWORK
ASSEMBLED WITHIN TWO NET LAYERS,
MACHINE QUILTED

55"H X26"W

Storms are driven by the conflict-
ing movement of warm and cool
air, something that we can feel
but cannot see. What we do see
are the things that are picked up
by the storm, such as raindrops or
dust or cinders. In this quilt I have
tried to capture the swirling fluid
character of that movement as the
air seeks equilibrium.

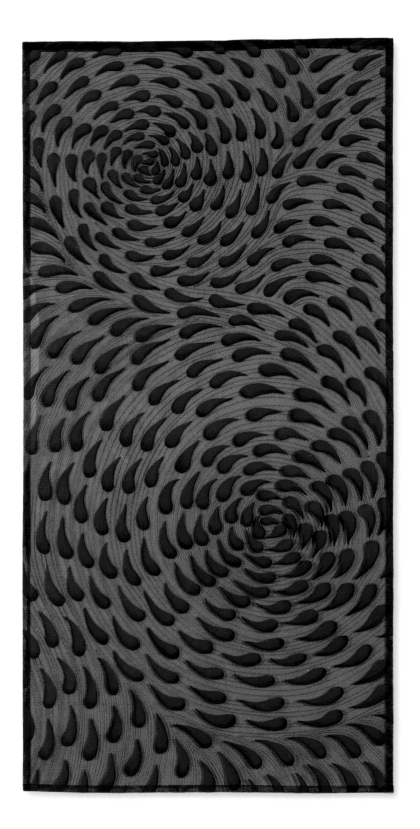

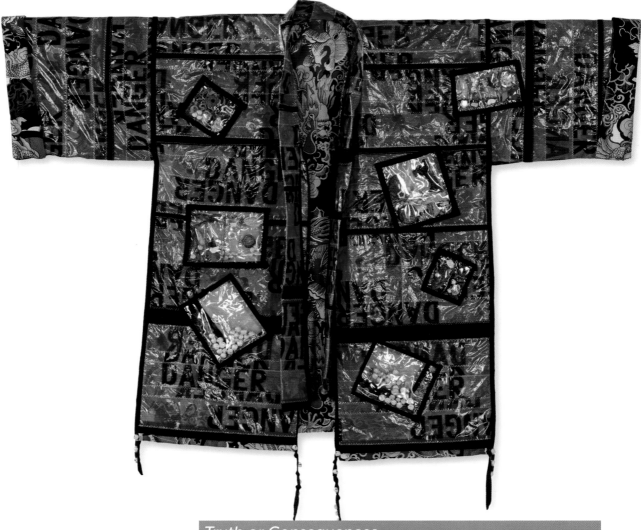

Truth or Consequences

Arle Sklar-Weinstein

HASTINGS ON HUDSON, NEW YORK

CATHY RASMUSSEN EMERGING ARTIST MEMORIAL AWARD

2012; RED DANGER BARRICADE TAPE, VINYL WINDOW POCKETS, FOUND OBJECTS OF DEBRIS, COMMERCIAL COTTON (FIRE BREATHING DRAGON); KIMONO FORM, APPLIQUÉD

48"H X 54"W

Creating visual art in any form often results in something attractive or beautiful to enjoy. To use art as a political statement without falling into illustration is in my experience, more challenging.

In this Kimono form, *Truth or Consequences*, the medium is truly the message; barricade tape to create the "fabric" amplifies the warnings of irreversible environmental damage we humans in our folly and greed, continue to inflict on our planet.

Letters to Myself—Page 4

Denise Linet

BRUNSWICK, MAINE

LYNN GOODWIN BORGMAN AWARD FOR SURFACE DESIGN

2012; HAND DYED COTTON, SILK ORGANZA, POLYESTER SHEER, NEWSPAPER, PERMANENT PEN; MACHINE PIECED, HAND AND MACHINE STITCHED, SHAPE RESIST DYED, DIGITAL TRANSFER, ARTIST MADE THERMOFAX SCREEN-PRINTED, PAPER LAMINATION, DIRECT WRITING

41"H X 31"W

Letter to Myself—Page 4 is a reflection on the transient nature of life. With the passage of time there is a transience depicted with traces, recollections, faded memory and layers. I consider my work as an ongoing process of searching for meaning and deciphering the metaphors.

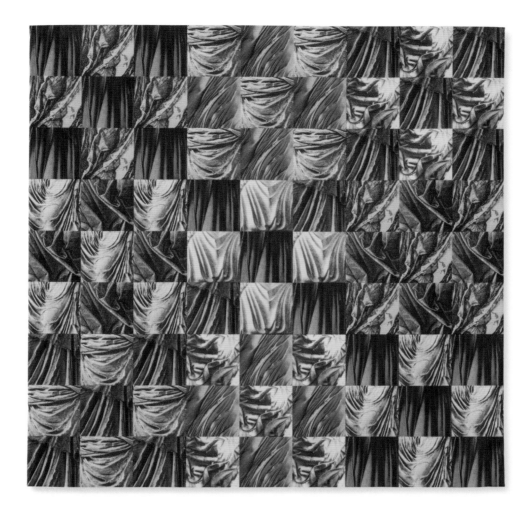

Martha Warshaw

CINCINNATI, OHIO

2012; COTTON; INKJET PRINTED, HAND-PIECED, TIED

24"H X 24"W

This is one in a series about depictions of textiles in artwork. It consists of constructed images (combinations of manipulated photographs) printed on fabric and assembled to form a nine-patch block.

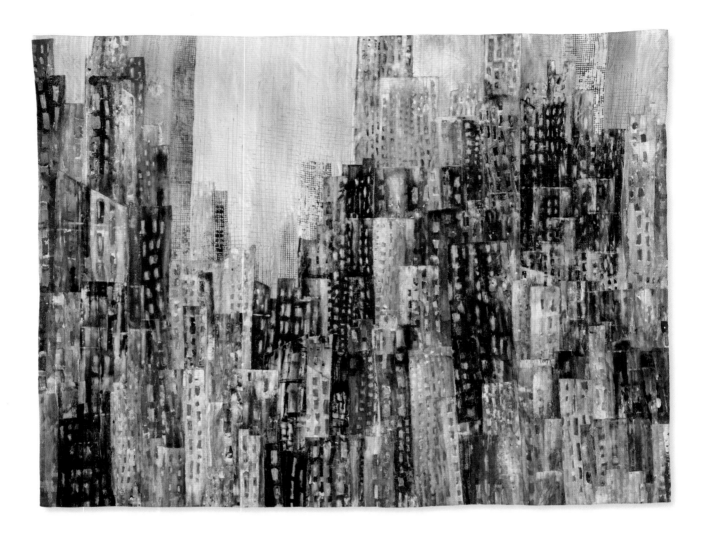

Central Park West Sunrise

Linda Levin

WAYLAND, MASSACHUSETTS

2012; COTTONS AND BLENDS; HAND PAINTED, MACHINE PIECED, MACHINE QUILTED, RAW EDGES

45"H X 58"W

My quilts are made with fabrics I paint to achieve effects that I couldn't obtain from purchased fabrics. My inspiration comes from places I've seen and stored away in my memory. I try to capture not a specific scene, but an atmosphere, a mood or a moment. The tactile qualities of the fabric, the light and shadow created by seams and raw edges and the interplay of colors provide endless opportunities for exploration.

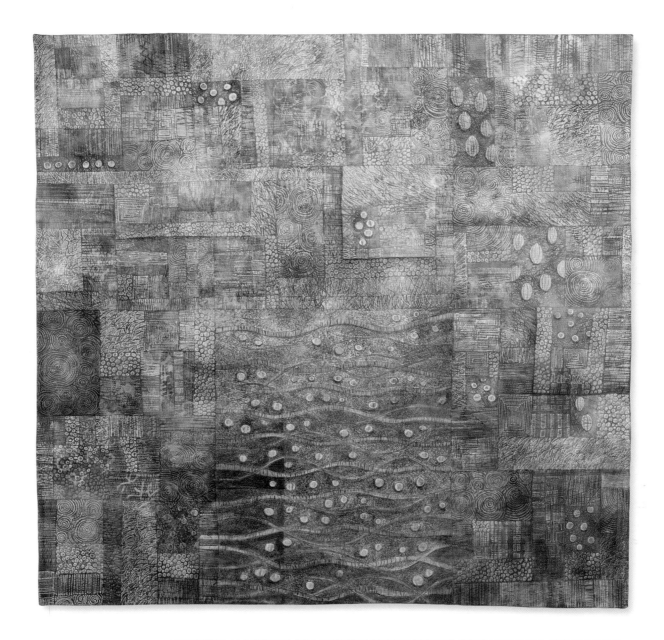

Tracings III

Deidre Adams
LITTLETON, COLORADO

2011; COTTON FABRICS, ACRYLIC PAINT; MACHINE STITCHED, HAND PAINTED

60"H X 60"W

Inspired by the structural elements and seductive surfaces of old buildings and walls, I explore ideas of time and transformation. An old wall tells a story, like a canvas upon which both nature and human beings play and leave their marks. Over the course of many years, layers of paint and graffiti are applied, only to be eroded by sun, rain, and wind. The result is a surface rich with texture and color.

Sara Impey

COLCHESTER, ESSEX, ENGLAND

Bitter Pills

2012; COMMERCIAL COTTON, FELT BATTING,
POLYESTER THREADS; WHOLE CLOTH,
MACHINE QUILTED

58"H X 38"W

Drug capsules are often attractively coloured, diverting attention from the unpleasant medical conditions they are designed to treat. This list of the 'bitter pills' that face society also includes examples of inadequate responses by political leaders and the general population, such as 'wishful thinking' and 'tunnel vision'. The future looks bleak—but the single monochrome capsule at the end is intended to sugar the pill.

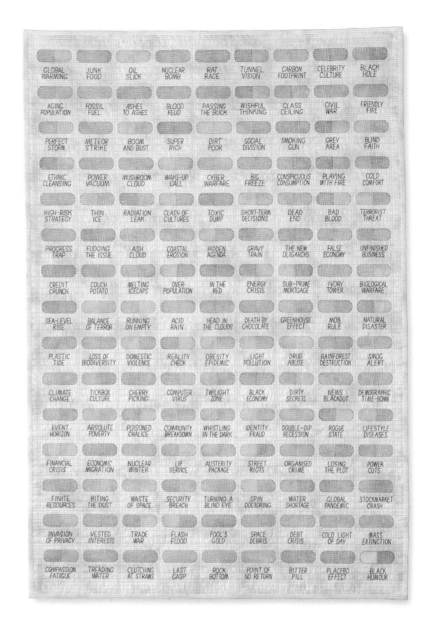

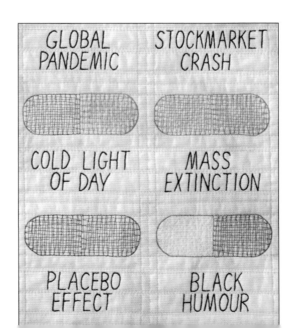

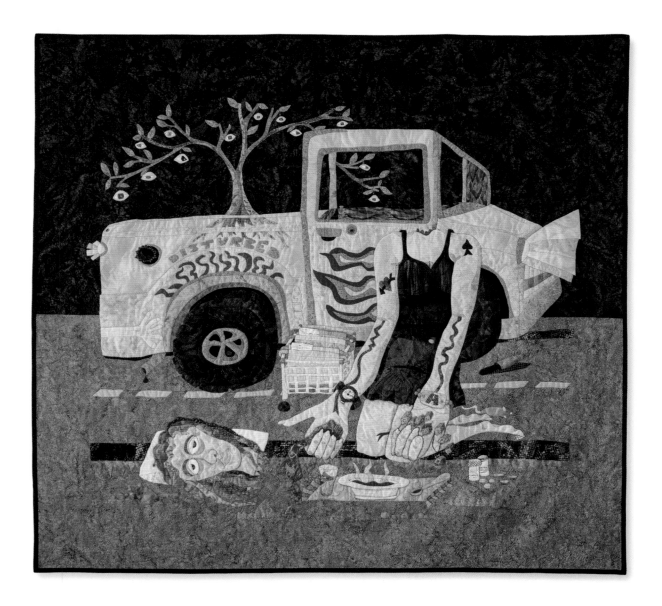

Spread Out on the Pavement

Kathy Nida

EL CAJON, CALIFORNIA

2012; HAND-DYED AND COMMERCIAL COTTONS, COTTON EMBROIDERY THREAD, INK; FUSED, MACHINE APPLIQUÉD, MACHINE QUILTED, HAND EMBROIDERED, HAND INKED

67"H X 72"W

This is one of those dreams, nightmares really, that doesn't go away. Everything is laid out before you, the strangest things surround you, and there doesn't seem to be any way to escape it, whatever horrible thing IT is. You can't see straight. You're trying to pick up the pieces, but nothing works right, and it all falls through your fingers. Laid bare.

Riveted

Sidnee Snell

CORVALLIS, OREGON

2012; COTTON, DYE, COTTON THREAD, BATTING; RAW-EDGE APPLIQUÉD, MACHINE QUILTED

30"H X 31"W

The effect of nature on man-made objects fascinates me. This piece is based on images of the Steel Bridge that spans the Willamette River in Portland, Oregon. The rain and weather have worn away areas of the black paint allowing beautiful patterns of worn and faded paint, and rust to form.

Hands off!–Hau ab!

Brigitte Kopp

KASEL-GOLZIG, GERMANY

2012; COTTON, SILK, LINEN, COMMERCIAL BATTING, COTTON THREAD, SATEEN RIBBON, BUTTONS; WHOLE CLOTH WITH APPLICATIONS, MACHINE PIECED, HAND AND MACHINE QUILTED

52"H X 42"W

There are still children in our society suffering from several childhood traumas. It takes a long time until they can say, 'Hau ab!' (Hands off!). We should learn to read their signals and not look away.

Brienne Elisabeth Brown

BARRINGTON, RHODE ISLAND

Moonset

JUROR'S AWARD OF MERIT

2011; SILK, COTTON, COTTON BATTING, COTTON THREAD; WHOLE CLOTH, FREE-MOTION MACHINE QUILTED

50"H X 35"W

One beautiful and very early morning, I made my way to the beach in LaJolla and saw the full moon setting over the Pacific.

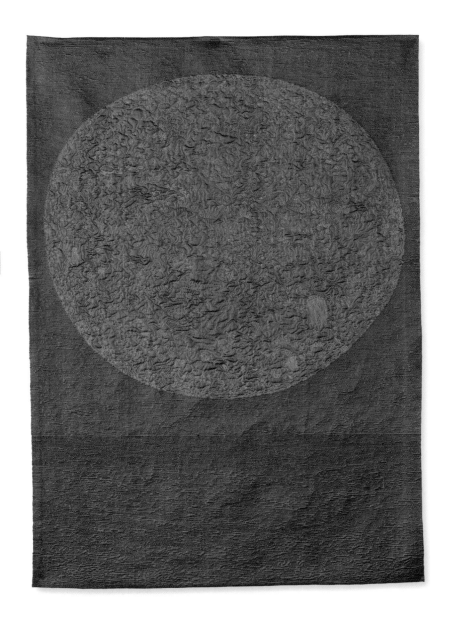

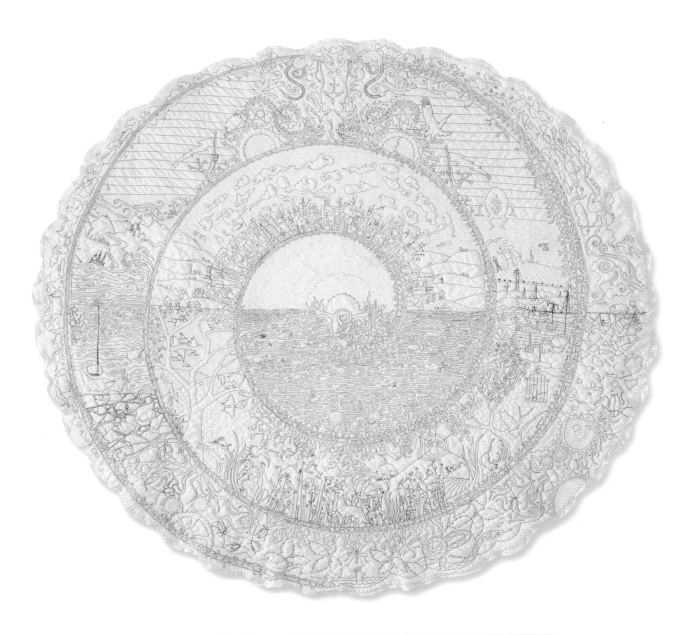

Round and Round It Goes

Paula Kovarik

MEMPHIS, TENNESSEE

AWARD OF EXCELLENCE

2012; COTTON TABLECLOTH, BAMBOO BATTING, COTTON THREAD; THREAD DRAWN

54"H X 54"W

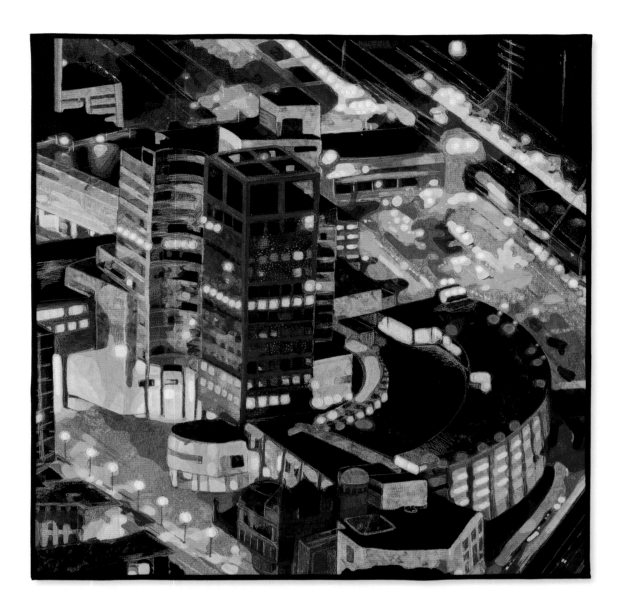

Morgan's Flight

Kate Themel

CHESHIRE, CONNECTICUT

2012; COTTON, DYE, RAYON AND POLY THREAD, COTTON BATTING; DYED, RAW-EDGE MACHINE APPLIQUÉD, FREE-MOTION MACHINE QUILTED

38"H X 38"W

Morgan's Flight depicts a nighttime aerial view of Bridgeport Center in Bridgeport, CT. The glow of artificial light gives my once-familiar local environment a magical and alien appearance. This piece was inspired by the photography of Morgan Kaolian, a Bridgeport resident and professional pilot. Mr. Kaolian generously shared his photos with me as reference material (not photo transfer); used with his express permission.

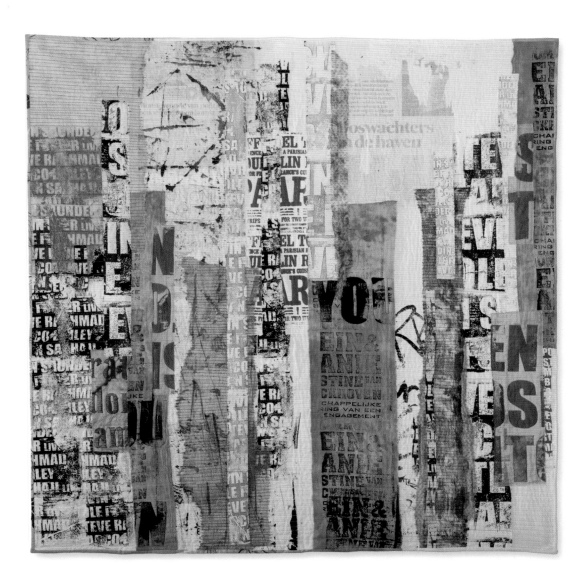

Jette Clover

ANTWERP, BELGIUM

2012; COTTON, ORGANDY, CHEESECLOTH, PAPER; PAINTED, SCREEN PRINTED, PAPER LAMINATED, SANDED, HAND AND MACHINE QUILTED

52"H X 52"W

My quilts are very influenced by my surroundings. I love living in the city with the haphazard layers of communication. I am especially inspired by the walls with torn posters, faded advertisements and overlapping graffiti. Seeing the fragmented traces of text on the walls, makes me wonder about the traces I myself will be leaving behind...

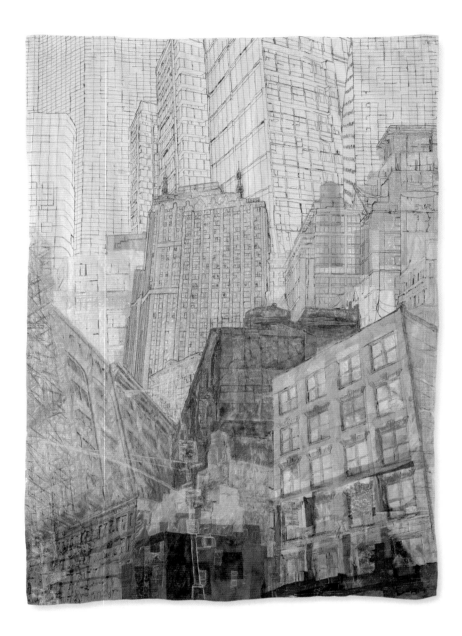

The City

Natalya Aikens

PLEASANTVILLE, NEW YORK

2012; VINTAGE LINEN, PAPER, OIL PASTELS, PLASTIC, DRYER SHEETS, COLOR CATCHERS; PAINTED, COLLAGED, MACHINE STITCHED,

56"H X 40"W

Architecturally inspired, delicately stitched: that is the motto for my art. The core of my art is deeply rooted in my Russian heritage and the architectural imagery of St. Petersburg and New York City. I feel strongly about using recycled materials such as paper, plastics and vintage fabrics. Computer photo manipulation, intense hand and machine stitching, and translucent effects are the techniques I favor.

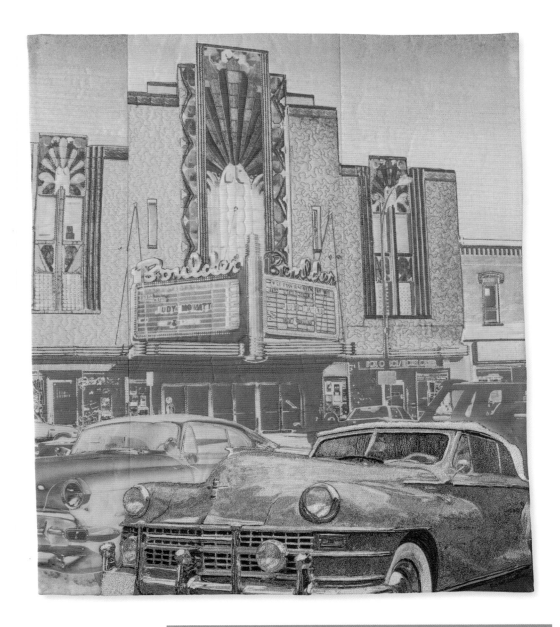

Vintage

Carol Watkins

LAFAYETTE, COLORADO

2012; COTTON, PIGMENT INKS, THREAD; PHOTOGRAPHICALLY PROCESSED, DIGITALLY PRINTED, APPLIQUÉD, THREAD PAINTED, FREE-MOTION QUILTED

26"H X 22"W

The Boulder Theatre currently shows films and presents live performances. In my imagination I turn back the clock to an earlier time period and see the street lined with vintage automobiles as people arrive for the theatre performances.

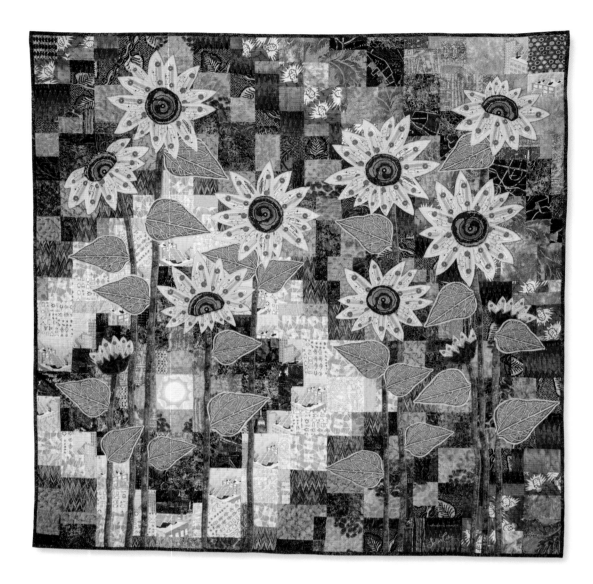

Solar City

Katherine Knauer

NEW YORK, NEW YORK

2011; COTTON FABRICS (ORIGINAL DESIGNS), COMMERCIALLY PRINTED FABRICS, CUT SILK VELVET THREAD; MACHINE PIECED, HAND APPLIQUÉD, HAND QUILTED

86"H X 86"W

Original fabric prints of solar panels on rooftops, electrical symbols, energy-saver light bulbs suggest on optimistic vision of the future. The sunflower petals are actually bright yellow taxis and the veins of the leaves are city street maps with street names such as "Recycle Road" and "Sunshine Street". Visual puns such as use of the traditional "Sunshine and Shadow" quilt pattern are referenced.

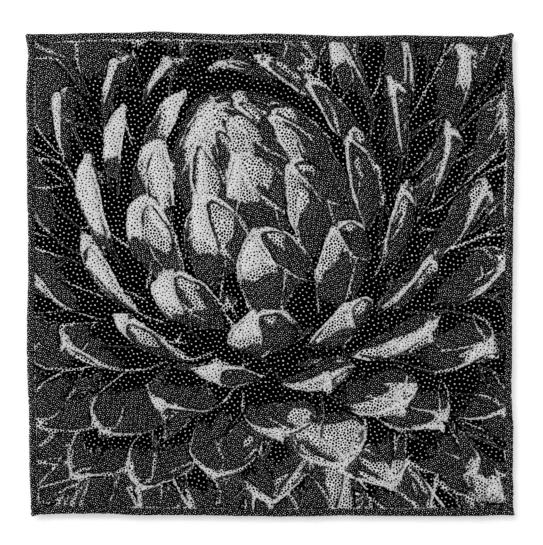

Agave In Black & White

Kathleen McCabe
CORONADO, CALIFORNIA

2011; COMMERCIAL COTTONS, BATTING, THREAD; MACHINE APPLIQUÉD, REVERSE APPLIQUÉD, MACHINE QUILTED

24"H X 24"W

I love the play of light and shadow on succulents.

ABOUT THE DAIRY BARN

For nearly four decades the Dairy Barn Arts Center has been evolving into a first-class arts center with 6,000 square feet of exhibition space. Renovation architects retained the original character of the barn without sacrificing the design, climate control, or security features that make it a state-of-the-art, accessible cultural facility. In 1993 the Ann Howland Arts Education Center was built to house the Dairy Barn's growing art class and workshop program. A capital campaign led to the 2001 renovation and expansion of an additional 7,000 square feet previously undeveloped on the second floor. The space now includes five rooms for performing and visual arts classes and community events.

The Dairy Barn Arts Center's mission is to nurture and promote area artists and artisans, develop art appreciation among all ages, provide the community access to fine arts and crafts from outside the region, and draw attention and visitors to Southeast Ohio. The twelve-month program calendar includes international juried exhibitions, touring exhibits, festivals, programs of regional interest, live performances, and activities for all ages. Some events are produced entirely by The Dairy Barn Arts Center while others are the result of cooperation with regional education, arts, or community organizations. Exhibits such as *OH+5* and *Athens Voices* feature outstanding regionally-produced artwork in a variety of media. The Dairy Barn Arts Center has also developed an international reputation for excellence with *Quilt National,* a biennial exhibition that has attracted more than 100,000 visitors to Athens from around the world since its premiere in 1979.

The Dairy Barn Arts Center is supported by admissions, memberships, corporate sponsorships, grants, and exhibition tours and art sales. The full-time staff of five is assisted by a corps of more than 200 volunteers, who donate thousands of hours annually.

The Dairy Barn Arts Center's top-notch exhibitions and programs, its reputation in the international arts community, its close proximity to Ohio University, and its picturesque setting make it an important stop on the itinerary of many visitors. The Dairy Barn Arts Center has added significantly to the Athens area's reputation as a cultural center. Both Athens and the Dairy Barn have been featured in the book, *The 100 Best Small Arts Towns in America*, and Athens was mentioned in *USA Today* as one of the ten best arts-centered communities in the country.

For a calendar of events and information about any Dairy Barn programs, contact the Dairy Barn Arts Center, P.O. Box 747, Athens, Ohio 45701; phone 740-592-4981; or visit the website at www.dairybarn.org.

Quilt National '13 Tour Schedule

May 24, 2013–Sept 2, 2013
Dairy Barn Arts Center
Athens, OH

Sept 20, 2013—Oct 27, 2013 (A, B and C)
St. Louis University Museum of Art
St. Louis, MO

Jan 15, 2014—April 13, 2014 (C)
The Riffe Gallery
Columbus, OH

May 6, 2014—July 20, 2014 (A and B)
The San Jose Museum of Quilts and Textiles
San Jose, CA

Sept 1, 2014—Dec 31, 2014 (A or B)
Historical and Cultural Society of Clay County
Moorhead, MN

Artist Index